Barron's Art Handbooks

HOW TO RECOGNIZE STYLES

HOW TO RECOGNIZE STYLES

BARRON'S

4

CONTENTS

WHAT IS STYLE

Historical, religious, and human factors combine to influence and shape the style of a work of art. *An artistic style is a combination of iconographic, technical, and compositional features that give a work its character and allow it to be attributed to a particular school or period.* Therefore, when we speak about styles such as Romanesque, Gothic, or Impressionist, we are referring to an aesthetic form of expression, which reflects a vogue prevalent during a given period. When we speak about the style of individual artists, we take into consideration their personality traits as well as traits peculiar to their contemporary culture.

Art as Expressed Ideas

People conceive ideas and need to share them. This need for expression is what stimulates artistic activities whereby an artist might use materials, colors, words (written or spoken), body language, or sounds.

Everyone has ideas and needs to communicate them. This does not mean, however, that everyone is an artist, because *a work of art is not just an idea: it is an expressed idea.*

A work of art is born only when ideas or feelings crystallize into finished products that are created through masterly applications of a skill.

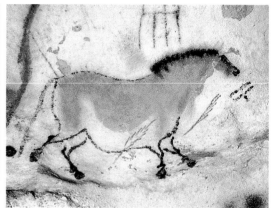

Horse *(circa 10,000 BC).*
Cave painting from Lascaux, Dordone, France.

Social Motivations of Art and Its Modes of Expression

We have said that art arises from the need to express something, but to express what and, more importantly, how?

The deep underlying motives that stimulate artistic creation are independent of time because *the value of an artwork depends more on how a subject is expressed than on what the subject is.*

Culture and art are inseparable, interactive, and complementary concepts. In every culture, art has traditionally fulfilled social aspirations: *religious* (at the service of a dogma, an ethic, or a priestly class), *military* (exalting a hero or displaying patriotism), *political* (glorifying a leader), etc. These goals, coupled with the quest for pure aesthetic enjoyment, can result in different forms of artistic expression:

A) *Symbolic* This form of artistic expression results when an artist embodies some aspect of a human law, religion, or morality in

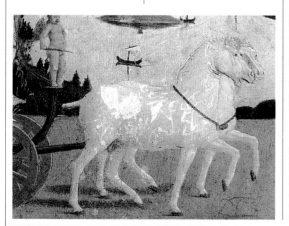

Piero della Francesca.
Horses from the Diptych of the Dukes of Urbino *(about 1465). Uffizi, Florence. Throughout the history of art, what distinguishes an artist's work lies not in what is being said but in how it is said.*

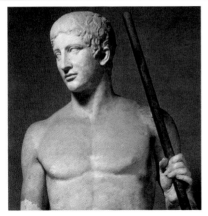

Polycletus. Fragment from the Doríforo (fifth century BC). Classical artwork.

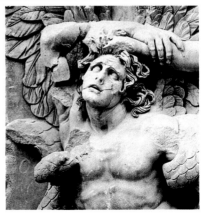

Detail from the Gigantomachia, from the Pergamum Altar (second century BC). State Museum, Berlin. Baroque Work of Hellenism.

an image. Generally rooted in ethical principles, the purpose of these kinds of works is to bring about awareness and acceptance of certain moral and religious truths.

B) *Classical* This form of artistic expression results when an artist is motivated solely by his or her own emotional feelings. Classical works seek, more than anything else, to provide aesthetic pleasure based on harmony, tranquillity, and perfection.

C) *Baroque* This form of artistic expression results when an artist is less concerned with balance and serenity and more interested in expressing his or her search for beauty through emotions, feelings, and highly dynamic, convoluted shapes.

D) *Romantic* This form of artistic expression results when an artist's goal is to appeal to the viewer's emotions. Many paintings inspired by literary, historical, or legendary accounts come under this rubric.

Bear in mind that when we speak about symbolic, classical, baroque, or romantic works, we are referring only to different types of expression, not to historical periods.

Main Ideas

• Style refers to the combined traits of a work of art that allow it to be placed into an historical context and attributed to a particular artist.
• A work of art is an *expressed* idea that results from the masterly application of a skill.
• A work of art is a craft activity and a social undertaking that finds expression as either symbolic, classical, baroque, or romantic creations.

Géricault. Detail from The Egyptian Campaign (circa 1814). Pencil and watercolor drawing. Louvre, Paris. The dynamic and tragic stance of the horse defines the romantic character of the work.

IMPORTANT CONCEPTS

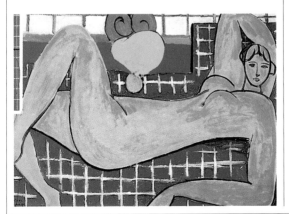

PRINCIPAL TENDENCIES IN ART

Artistic styles reflect one of four tendencies: *naturalistic, cerebral, rhetorical,* and *decorative or abstract.* Philosophical principles hold that human imagination manifests itself in two ways. According to Kant (eighteenth-century philosopher), the two facets of imagination are reproductive and combinative. When reproductive imagination dominates artistic activity, the work of art reproduces natural forms. When the combinative aspect dominates, reality is distorted and is expressed artistically in cerebral forms.

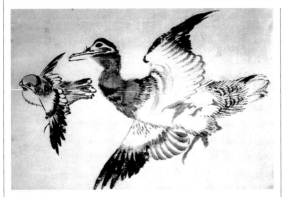

Katsushioka Hokusai (1760–1849) Flying Birds. *In his personal style, the Japanese artist gives us a naturalist vision of several birds in full flight. No image distortion is evident.*

The Naturalist Tendency

An artwork displays aesthetic naturalism when it interprets the factual truth about forms corresponding to the object observed. An animal, for example, can be painted in a naturalistic manner regardless of the historical period in which it is produced. While stylistic traits will distinguish, for example, a Paleolithic painting from an Etruscan, Greek, Gothic, or Renaissance one, the painting will always produce the natural form of a real animal.

Main Ideas

- A work of art can reflect four tendencies: naturalistic, cerebral, rhetorical, and decorative or abstract.
- Human imagination can be reproductive or combinatory.
- Tendencies in art are not restricted to any particular time period. Naturalism and the cerebral tendencies have repeatedly emerged throughout the history of art.

The Cerebral Tendency

This tendency implies a *formal distortion* of observed reality. The combinatory imagination leads the artist to represent an intellectual (unreal) truth that is expressed through stylized shapes.

It should be noted that the very nature of artistic expression always implies modification, to a certain degree, of the natural model. Here, however, we are referring to intellectual interpretations of natural forms that become in themselves the essence of an art style.

The Rhetorical Tendency

This tendency is characteristic of romantic paintings and is always evident in works whose aim is to convey a message or tell a story. Examples of rhetorical tendencies can be found

Matisse. Pink Nude *(circa 1930). The artist alters the natural forms of the female body into a totally cerebral image.*

throughout the history of art, from prehistoric hunting scenes and Egyptian paintings, to large Renaissance, Baroque, and Neoclassical murals.

The Decorative or Abstract Tendency

Because people are naturally drawn to great naturalistic art, they often show little interest in decorative or abstract art—that is, to non-figurative, conjectural art that creates meaningless images unrelated to natural forms. Purely decorative geometric art falls into this latter category and has produced exceptional works found in several prehistoric and protohistoric cultures and in Oriental art.

Naturalism and Abstraction in Paleolithic Art

Archaeologists date the first prehistoric cave paintings from 15 or 16 thousand years ago. Because these paintings represent true wonders of rhythm and color, we are tempted to think that *art was born highly developed and with naturalistic qualities.*

When Paleolithic men covered the walls of their caves with animal figures, they were not responding to an artistic impulse. More than likely, these prehistoric artists were engaging in a fertility magic ritual when,

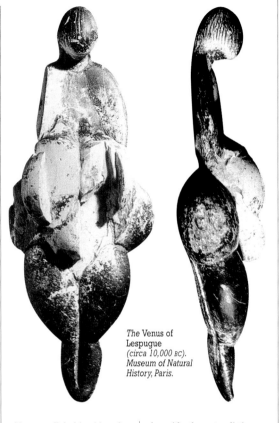

The Venus of Lespugue *(circa 10,000 BC). Museum of Natural History, Paris.*

with unparalleled intuition, they engraved, painted, or sculptured fleeting visions of animals in motion or majestic figures of stationary animals on the rock walls of their caves.

However, the discovery of small stylized figurines of female idols, such as the *Venus of Lespugue,* alongside the naturalistic cave paintings illustrates an important point: art, from the Paleolithic to the present, has manifested itself not only through naturalism but, at the same time, through cerebral tendencies that are expressed in stylized, "geometric" natural forms.

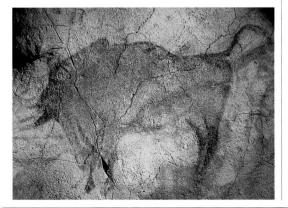

Bison from the Altamira Cave (circa 10,000 BC). Santander, Spain. Concurrent with naturalist manifestations (Altamira), Paleolithic art creates remarkably striking cerebral forms such as those of the Venus of Lespugue.

ENVIRONMENTAL CHANGES, HUMAN AND ARTISTIC EVOLUTIONS

Around 10,000 BC, a large climatic change took place on Earth. The last glacial period drew to a close and the ice that covered what is now continental Europe migrated northward, along with the animals who could thrive in cold climates. Thus began the long Neolithic Age in which mankind had to learn to adapt to life outside of caves and to depend more on agriculture than hunting. From this dependency, herding and farming were born. The transition from the Paleolithic to the Neolithic Age did not, of course, happen overnight but over thousands of years in which humans slowly adapted to the changing environment and to the needs of a sedentary life.

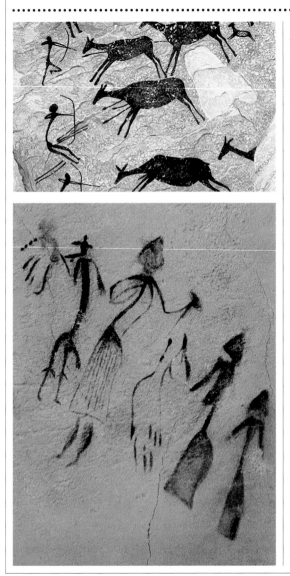

Hunting Scene. *Neolithic cave painting of La Valltorta, Castellón de la Plana, Spain.*

Appearance of the Rhetorical Tendency in Art

Following this adaptation to the environment, a new society emerged that had strong ties to the land it cultivated and that was now characterized by a stable population sharing common interests. Over the course of many years, new and different cultures evolved in which social roles became more complex, and superseded the family nucleus. Art reflected this role, developing a marked taste for formal synthesis. This is evident in the prehistoric cave paintings called the *Levante Español* (dating to about the eighth century BC) which represent a radical change from Paleolithic paintings.

Rather than mere sacrificial offerings, the animals in the Altamira or Lascaux paintings are god-like images in that they represent forces beyond human control. On the other hand, the animals in the pictorial sequences of the *Levante Español* no longer convey a magical significance. They have become smaller and are no longer the main protagonists of the mural, a role they now share with both male and female human figures. While these paintings undoubtedly have a magical-religious meaning, for the most part they are

Fertility Dance. *Neolithic cave painting from Gógul de las Garrigues, Lleida, Spain.*

rhetorical portrayals whose aim is to narrate, perhaps for illustrative or commemorative purposes, common occurrences of everyday life that would be meaningless without the presence of man.

The black and red silhouettes of the animals are depicted in a very naturalistic way and sketched with extraordinary precision. The human figures are highly stylized and display surprising spontaneity and simplicity in their movements.

These paintings also show, for the first time, a certain penchant for composition and spatial structuring where the Neolithic artist did not exclusively focus on individual images, but was more interested in the narrative as a whole.

Emergence of Decorative or Abstract Art

The climatic change also altered eating habits, producing one of the most extraordinary inventions of humankind: pottery making. This development, which was responsive to daily exigencies, also opened an uncharted area of aesthetic activities.

Once the technique for modeling and firing clay was mastered, practical considerations suggested the adoption of different shapes for different uses of the clay containers. In other words, containers that were to be used for cooking foods had to be shaped differently from those for carrying liquids.

Pottery then, as far as its *raison d'être* was concerned, became a finished product, in the same way that a swallow's nest, which is always the same, is.

Why then has man, from time immemorial, deviated from practicality and conceived different shapes for ceramic objects that serve the same purpose?

To conceive shapes and work the material by molding, casting, and sculpting, is in itself an important aesthetic activity which, from an artistic point of view, should be considered totally independent from that of complying with the intended uses of the manufactured object.

It should be understood, for example, that the artistic value of a clay jug, for example, does not lie in the fact that it is a jug, but in the shape it has been given.

Pottery making, then, awoke in primitive mankind an aesthetic feeling that led him to conceive diverse shapes (a completely abstract artistic manifestation) and to an equally abstract artistic activity: the decoration of surfaces with geometric motifs.

It's important to realize that pottery making, from pre-historic times to the present day, fulfills a human need: *to create things that are not only useful but also beautiful.*

Main Ideas

• During the Neolithic Age, man increasingly relied on land cultivation and slowly abandoned hunting.
• Neolithic painting is characterized by a rhetorical tendency, evidenced by the portrayal of highly stylized human figures.
• Animals are depicted in great detail in black or red silhouettes.
• Ceramic art first appeared during the Neolithic Age and yielded the first manifestations of abstract art.

Prehistoric terracota vase decorated with incised horizontal bands (circa 2,800 BC). Museum of Archaeology, Barcelona.

Greek pottery with geometric design (eighth century BC). Museum of Archaeology, Barcelona.

HIERATIC EXPRESSION IN ANCIENT ART

The hieratic (from the Greek *hieratikós*, priestly) quality in art *is an aesthetic form of expression that is found in archaic works and that is characterized by rigid, solemn, and expressionless figures commonly seen in archaic religious iconography.*
Hieratic art usually appears when a dominant social class imposes an "official art" that pleases the elite. The images of the figures are rendered solemn through rigid features and cold expressions.

Hieratic Expressions in Ancient Egyptian Painting

The hieratic expression in Egyptian art resulted from rigid norms imposed by a priestly class for more than three thousand years.

However, Egyptian art also shows how artistic sensitivity can overcome dogmatic requirements intended to inhibit it. In fact, the best Egyptian paintings, though following rigid pharaonic style, display a subtle exquisiteness embodied in sensitive and elegant drawings.

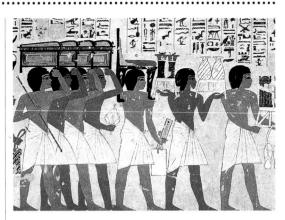

Funeral Procession. *Tomb of Remose (fifteenth century BC). Thebes. The figures in this ritual scene follow the law of frontality.*

The Laws of Egyptian Art. Law of Frontality

The reason why the Egyptian art style endured for so long was because of its continued adherence to two laws: *the law of frontality* and the *law of hierarchy*.

In painting and bas-reliefs, the law of frontality prescribed that the representation of the human body abide by the following rules:

• Faces always had to be rendered in profile, with one eye visible from the front.
• Shoulders and torsos had to be shown in front view. Female torsos could show only one breast in profile.
• Arms and legs had to be shown in profile, with the limb closest to the viewer in a trailing position.

• Standing figures always had to have their two feet planted firmly on the ground.

These rules did not apply to portrayals of animals and figures, particularly workers, musicians, dancers, etc., engaged in various mundane activities.

The Law of Hierarchy

There is a fresco from a Thebes tomb in the British Museum that depicts a bird-hunting scene. This work is one of the best examples of the exquisite naturalism Egyptian artists were capable of when the subject matter, such as a group of birds, allowed for such informality.

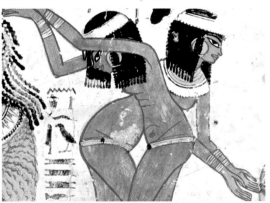

Egyptian Dancers. Nebamon's Tomb (fifteenth century BC). Thebes. British Museum, London. The hieratic quality required by the law of frontality is softened in the depiction of workers of different professions.

Environmental Changes
Hieratic Expression in Ancient Art
Pre-Hellenic Painting. Cretan Painting

13

The scene depicts three figures, a male hunter, a woman and a slave girl, whose decreasing size conveys their relative importance.

According to the law of hierarchy, the size of the figures in a scene had to be scaled according to their social standing.

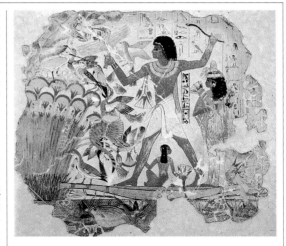

*Marsh Hunting Scene.
Nebamon's Tomb (1450–1350 BC).
British Museum, London.
Good example of an application
of the law of hierarchy and of
a naturalistic representation
of animals.*

Main Ideas

• Hieratic expression is the aesthetic form whereby figures are portrayed with solemnly rigid features and postures.

• Egyptian and Mesopotamic art conforms to the hieratic law of frontality in the representation of human figures.

• Egyptian and Mesopotamian works offer exquisite examples of naturalistic art, particularly in the portrayal of animals.

• Another rule commonly followed in ancient art is the so-called law of hierarchy whereby the size of figures in a scene are made proportionate to their social standing.

The Hieratic Expression and Frontality in Mesopotamic Art

The art of all ancient cultures of the Near East followed the principles set by the law of frontality according to which *profile was the single most salient feature of a living being.*

Both the paintings and bas-reliefs of Mesopotamic cultures followed this norm when glorifying, in an eminently hieratic style, such kings as Sargon, Darius, Nabuchodonosor, Senaquerivo, and Ashurbanipal.

Effigies of kings and high-ranking officials are common in Mesopotamic art. The solemn-faced figures are always seen in profile, with only one eye visible to the viewer and adornments and clothing rendered in great detail. Their arms and legs are quite muscular and also drawn in profile. So are their torsos and shoulders, which often seem awkward in a front view.

Mesopotamic art also displays naturalist tendencies, particularly evident in Assyrian works depicting animals. The sensitive manner in which the animals' suffering is expressed contrasts with the hieratic attitude used to portray the human figures.

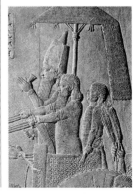

*Ashurbanipal in His Victory
Chariot. Bas-relief from the
palace at Nineveh, (668–626 BC).
Louvre, Paris.
Although the frontality in
Mesopotamic art differs from that
in Egyptian art, it still preserves
the same absolute hieratic form.*

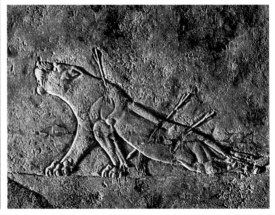

*The Wounded Lion.
Fragment from the relief
"Ashurbanipal on a Lion Hunt."
(668–626 BC). British Museum.
The Assyrian artist's full emotive
capability is conveyed in this
masterful animal scene.*

PRE-HELLENIC PAINTING. CRETAN PAINTING

Several important civilizations, which flourished on the coast and islands of the Aegean Sea between 3000 and 1200 BC, acted as a cultural bridge between East and West. In particular, the painting style that evolved on the island of Crete brought a different outlook to art and heralded new ways of artistic expressions. This art is called Cretan or Minoan, a name derived from the legendary King Minos of Crete. Although it features Oriental influences, *Minoan painting does not conform strictly to a hieratic design, but is permeated by naturalism in the depiction of common events in daily life.*

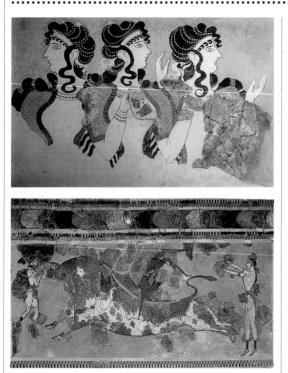

Ladies in Blue *(circa 1500 BC). Fresco from the Knossos Palace. Candia Museum, Crete.*

elongated body and horns of the bull that project forward as if suggesting strength and speed.

Towards the year 2000 BC, Crete was invaded by the Achaeans, Eolians, and Ionians and was ruled by a military aristocracy. Despite the imposition of official art standards and a return to hieratic forms, their imposition could not, however, completely overcome the innate elegance that characterizes Cretan art.

Styles of Primitive Greek Painting

Our knowledge of primitive Greek painting comes from vase paintings whose origins can be traced to Minoan and Mycenaean art.

Dipylon Vases (Eighth Century BC)

These are large funeral vases decorated on a black background. Frets, triangles, squares, and other shapes are arranged in horizontal bands and are supplemented by friezes in which the dark silhouette of a highly cerebral and synthetic animal or anthropomorphic figure is repeated. Friezes depicting funeral rites occupy almost the entire surface of the vase.

The Proto-Corinthian Style (Seventh–Sixth Centuries BC)

The Proto-Corinthian style features decorative motifs based on

Cretan Painting

Representative of the Cretan style of painting is the group of female figures known as the *Ladies in Blue* (Royal Palace of Knossos, circa 1500 BC). This painting has little in common with those of previous ages. While the frontality of the eyes and the torso suggests eastern influences, the elegance and the precision of the finely drawn figures and the casual demeanor and happiness reflected on the faces of the women in this very ancient painting, remind us more of contemporary

The Toreador Fresco *(circa 1500 BC). Fresco from the Knossos Palace. Candia Museum, Crete.*

art than that of the painters from Thebes, Nineveh, or Babylon. Other frescoes from Knossos deal with more "official" themes such as processions and bullfighting, highly important activities in ancient Crete. The hieratic form is again clearly visible in these frescoes despite their stylized look and dynamic scenes. The work known as the *Toreador Fresco* is remarkable for its stylization of the female athletes and the

The Hieratic Expression in Ancient Art
Pre-Hellenic Painting. Cretan Painting
The Hieratic Expression in European Painting

15

Oriental iconography such as the gorgon, the sphinx, the griffin, or the siren. Highly characteristic of this style are the meticulously worked details of the figures.

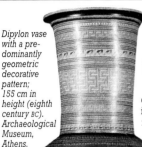

Dipylon vase with a predominantly geometric decorative pattern; 155 cm in height (eighth century BC). Archaeological Museum, Athens.

Styles of Attic Painting (Sixth Century BC)

After the Proto-Corinthian period, which spans the seventh and sixth centuries BC, Attic painting completely abandons the archaic and Athenian art styles of the sixth century and progressively embraces naturalism. In ceramics, two distinct painting styles emerge:

Black-figure pottery. Beginning in the first quarter of the sixth century BC, figures are silhouetted in black directly on red clay. The style reaches its highest form of artistic expression in the works of the painter and ceramic artist Exekias. Details, such as the folds of robes, hair, and adornments are etched with fine needles and take on the collective tonal value of the black and the reddish color of the background.

Red-figure pottery. (Middle of the Sixth Century BC). Exekias' successors, among them Euthymides and Euphronios, reversed the color pattern of the previous style. The figures were no longer painted black on the vase; instead the artists painted the background around the figures, leaving the figures the color of the red clay. The lighter color of the figures allowed the artists to concentrate on internal contours and highlight details of costumes, weapons, faces, hairdos, etc. This technique resulted in much more naturalistic figures in profile, frontal, or foreshortened poses. With Euphronios and Euthymides, all traces of Oriental solemnity disappear.

Main Ideas

• Our knowledge of Greek painting prior to classicism is derived from ceramic painting.
• Ancient Greek ceramic painting shows Mesopotamic and Cretan influences. In the sixth century BC, two styles evolved featuring black figures on a red background and red figures on a black background.

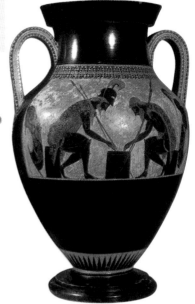

Exekias. Amphora: Ajax and Achilles Playing Dice (550–540 BC). State Collection of Antiquities, Munich.

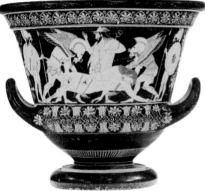

Euphronios. Attic krater with mythological scenes (510–500 BC). Louvre Museum, Paris.

THE HIERATIC EXPRESSION IN EUROPEAN PAINTING

Many of the elements in a work of art, which define its style and allow attributions to outside influences and other artists, cannot be traced to any single historical period.
Tendencies and styles that we call historical and that characterize specific eras, actually emerge in prior periods and continue into later ones.
Such is the case with hieratic art forms, which are not exclusively limited to ancient art nor are generally characteristic of an archaic epoch.

• •

Sixth-Century Byzantine Mosaic at San Vitale, Ravenna

Byzantine painting is, we might say, hieratic by necessity. The San Vitale mosaic shows Emperor Justinian, his attendants, and the Bishop Maximian. Despite the artist's clear intention to reproduce individual likenesses, the characters in the mosaic maintain a hieratic, elegant, solemn, and imperious posture, as if bestowing on the viewers the privilege of their important presence.

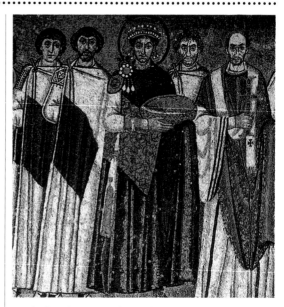

Emperor Justinian and His Attendants *(sixth century).* *Byzantine mosaic at San Vitale, Ravenna.*

Fifteenth Century. *La Verge dels Consellers*

The pose of the kneeling faithful with hands folded at their breast is one of the most characteristic images in Christian iconography. The solemnity apparent in these portrayals of people deep in prayer (whose faces display a profound intensity) is characteristic of the hieratic attitude found in many commissioned portraits.

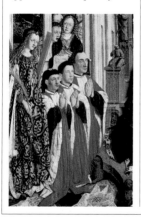

Lluís Dalmau. *Fragment of La Verge dels Consellers (fifteenth century). Catalonia Museum of Art, Barcelona.*

Sixteenth Century. *Knight with Hand on Chest*

This work is, without doubt, a masterwork and clear proof that hieratic portrayal does not preclude the display of emotional content.

An austere posture and frozen expression and gesture make the unknown knight a perfect example of a formal hieratic art.

However, as we contemplate the image of the knight, we cannot but sense a hidden spark of life that, at any moment will impel the knight to step out of the painting

Main Ideas

• Hieratic expression is the stylistic trait found throughout art history whereby an artist highlights the solemn or majestic in a person.
• The static and solemn character of a figure does not, however, preclude it from displaying emotional content.
• The distortion of forms as an interpretative exercise frequently leads to images that are clearly hieratic in nature—that is, static, rigid, and expressionless.

Pre-Hellenic Painting. Cretan Painting
The Hieratic Expression in European Painting
Classical Greek Painting

17

and explain to us, through gesture and words, what his eyes and hand fixed on his chest express.

Nineteenth Century (1811).
Tethys Imploring Jupiter

Hieratic tendencies are clearly evident in several works of master painters of the late Neoclassical period. The French painter Ingres' undaunted Jupiter with his impenetrable expression, symbolizes male dominance that the artist renders through the figure's exaggerated chest proportions and its affected severe hieratic pose. The same posture is also found in other equally imperious figures of different art epochs.

Vanguard Art of the Twentieth Century

It is common to find static and expressionless cerebral (individualistic and distinctive artistic ways of interpreting natural forms) figures in the evolution of new aesthetic trends. Often, it is a

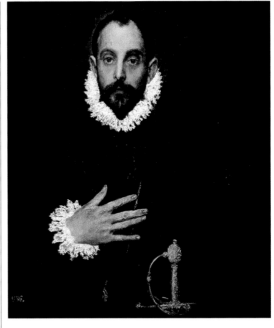

El Greco. Knight with Hand on Chest. *Prado Museum, Madrid.*

distortion of natural forms, such as that found in the *Venus of Lespugue* and in other examples through to the present, that gives the figures an unquestionable hieratic air. In Picasso's vast art production we find several examples of this hieratic quality, which the artist conveyed through distortion of spatial forms.

Ingres. Tethys Imploring Jupiter *(1811), Aix-en-Provence Museum, France*

Pablo Picasso. The Demoiselles of Avignon *(1911), fragment. Museum of Modern Art, New York.*

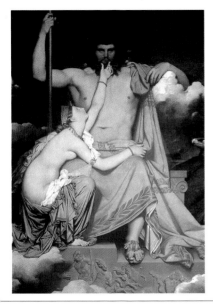

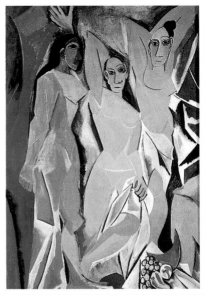

CLASSICAL GREEK PAINTING

The great paintings of ancient Greece have been almost entirely lost to us. What we know
about the great classical Greek artists has been handed down only through written materials,
painted vases, and Roman copies. Based on these sources, we can infer the following
as general stylistic traits of classical painting:
• A search for perfection in the human figure, as portrayed in paintings that are
given a "sculptured" look through chiaroscuro.
• A predilection for nature and life, passions and feelings.
• The integration of figures into a three-dimensional pictorial space.
• The portrayal of highly expressive figures that lack the solemnity of previous periods.
From the end of the sixth century BC to the end of the fourth century BC,
the classical Greek ideals of beauty and perfection find expression in the
works of the period's great artists.

Polygnotos

Polygnotos of Tassos was one
of the most celebrated artists
of antiquity. The Greek writer
Pausanias (second century BC)
mentions in his writings two of
Polygnotos' murals at Delphi (*The
Capture of Troy by the Greeks* and
Ulysses in Hell). Pliny the Elder, a
Latin writer of the first century,
also praises Polygnotos' painting
and his special talent for captur-
ing in his paintings the trans-
parency of female dresses.

Testimony of the
Lekythos Funeral Vessels

These long-necked ceramic
vessels, which contained per-
fume offerings to the dead, pro-
vide additional evidence on the
balance and serenity that charac-
terized classical Greek painting
of the fifth century BC.

The paintings on the Lekythos
depict mythological represen-
tations and musical or family
scenes. These are executed on a
white background with figures
silhouetted by fine line drawings
and light smatterings of color.

Artists, such as the so-called
Canneto Painter, display a good
command of drafting techniques
and a rare talent for preserving,
within a confined space, the natu-
ral elegance and monumentality
typical of the great painting of the
period.

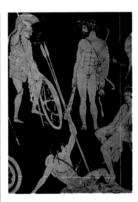

*Polygnotos of Tassos.
Amphora of the Niobides (detail)
(fifth century BC). Louvre, Paris.
The figures of the so-called
Amphora of the Niobides,
copies of Polygnotos originals,
reproduce the essential traits of
Greek painting of this period.*

Greek Painting of the
Fourth Century BC

During the fourth century,
painting shared with sculpting
the same aesthetic ideals of
elegance and serenity. Both
adhered to norms for portraying
the human body whose grace-
ful appearance was achieved
through prescribed proportions.

The painters of the fourth cen-
tury were particularly interested
in allegorical themes, portraits,
and the humanized representa-
tion of favorite deities such as
Aphrodite, Apollo, Artemis, and
Dionysius. Although our most

*White Lekythos (fifth century BC).
National Museum, Athens.
Lekythos painters preserved,
in a small space, the elegance
and monumentality of great
Greek painting.*

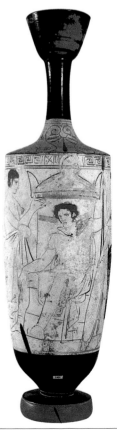

direct information comes from Roman copies of Greek works, we have documented evidence on schools and artists such as the Ionic School, which gave us *The Sacrifice of Iphigenia* by the master Timantes of Citnos.

The Sicione School

Two members of this school were Eupompos, revered painter from the Hellenist period, and Apelles, official painter of Alexander the Great who was also considered the greatest of the Greek painters.

The fresco *Hercules Discovers Telephus* from the basilica at Herculaneum (author unknown) belongs to the Apellian School and gives us a rough idea of what his paintings must have been like. *Aphrodite Anadiomena*, *Allegory of Calumny*, and *Alexander in His Triumphal Carriage* are other documented works of Apelles.

Apelles was a true innovator of composition who organized scenes consisting of closely grouped gatherings of figures placed on different planes. His realistic figures are rendered with perfect drawing techniques and subjected to rigorous modeling, which provides structure to the composition.

The Attic School

Members of this school include Aristides the Elder, Nicias, and Philoxenus of Eritrea. We know about the latter through a Roman mosaic known as the

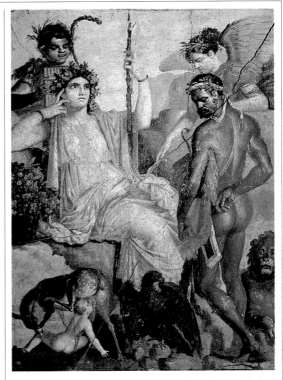

Apellian School (fourth century BC). Hercules Discovers Telephus. Roman copy. Basilica at Herculaneum.

Alexander Mosaic found at the House of the Faun at Pompeii. This work depicts the Battle of Issus fought between Alexander the Great and the Persian King Darius. The scene is quite violent and the artist displays masterful compositional skills and an understanding of perspective and motion, ethnic characteristics, and rendering of costumes.

Main Ideas

• Greek classicism peaked during the fifth and fourth centuries BC and set standards that sought perfection of form in every area of the plastic arts.
• Greek painting incorporated the concept of composition as we understand it today, a strong chromaticism, and an understanding of motion and perspective.
• Famous names in classical Greek painting include Polygnotos in the fifth century, and Timantes, Eupompos, Apelles, Philoxenus of Eritrea, and others in the fourth century.

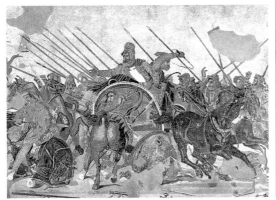

Alexander Mosaic, fragment. Philoxenus of Eritrea (fourth century BC). Roman mosaic (300 BC) copy of the original painting. House of the Faun, Pompeii.

HELLENISTIC PAINTING

Greek (or Hellenic) art which, because of Alexander's conquests, spread throughout his entire empire from Alexandria to cities in Asia Minor, is known as Hellenistic art.
Hellenistic plastic arts lost the harmony and balance of the classical period and gave way to a more dynamic and ornamental style, clear examples of which are the famous Laocoön Group or the reliefs of the Pergamum Altar.
In a more general sense, Hellenism is a taste for the Hellenic art style during any historical period, from Rome in the time of Augustus (first century BC) to Europe in the nineteenth century. It is in this sense that we refer to Hellenism in Roman painting.

Pompeian Styles

The frescoes at Pompeii and Herculaneum are the main examples from which we derive our knowledge of Roman and Greek painting (including Hellenistic art). The frescoes are murals that combine ornamental and architectural elements with figurative compositions in the Hellenistic style: mythological themes, scenes from everyday life, animals, and still lifes.

This type of painting is placed by experts into four groups known as the Pompeian styles.

Third Pompeian style. Wall panel from the House of the Vetti.

motifs painted on the walls depict figurative and usually mythological scenes.

The best examples are murals depicting various rites of the Dionysiac Mysteries, which are preserved in the large vestibule in the so-called Villa of Mysteries outside of Pompeii. Executed in a grandiose style and drawn with somber colors, the murals were most likely inspired by a classical or Hellenistic original.

First Style (Inlay)

This style evolved during the second century and part of the first century BC. Artists used high quality stucco to imitate different types and colors of marble paneling.

Inlaying is a decorative style whereby stucco craftsmen divided the wall space into areas that they embellished with decorative motifs such as skirting boards, moldings, and brightly colored friezes in predominantly red, yellow, and black colors.

Second Style (Architectural) (Middle of the First Century BC)

In this style, artists strive to open up the flat surface of the wall to imaginary urban landscapes drawn in elementary perspective. The architectural

Detail of the Dionysiac Mysteries *(first century BC). Villa of Mysteries, Pompeii. Balanced and structured figures bring this work close to Greek classicism.*

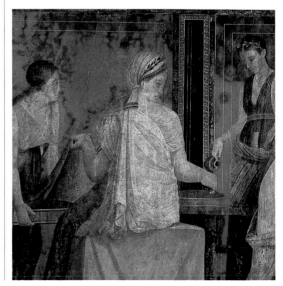

Third Style (Ornamental)

This style, which spans the years from approximately 14 to 63 AD, prevailed at the time of the eruption of Mount Vesuvius. The style is highly decorative and displays architectural elements of such great fantasy that they appear almost unreal. Walls are subdivided into compartments that frame decorative compositions containing garlands, figurines of Cupids, portraits, and other themes against red, green, or black backgrounds. A mythological theme, generally a reproduction of a Greek model, is painted on the central architrave soffit of each wall. The House of the Vetti and of Lucretio Fronton in Pompeii are representative examples of this style.

Fourth Style (Fantastical)

This style evolved during the period between the two Vesuvian catastrophes (between 63 and 70 AD).

Decoratively, it is a highly baroque style, with fantastic compositions that combine figures with chimerical animals, garlands, and other elements. Mythological themes, such as *The Three Graces* at the National Museum of Naples, are either copies of Hellenistic originals or are certainly inspired by them.

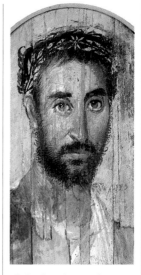

Fayium Portrait *(second century).*
Encaustic on wood.
National Gallery, London.
Magnificent example of antique
naturalistic portraiture.

Main Ideas

• Hellenistic art evolved as a modification of Greek classicism, which lost classical serenity and balance in favor of a true baroque style.
• Hellenism also refers to a taste for Hellenistic-style artworks which originated throughout the ages in all of the world.
• Roman painting is entirely Hellenistic as the four Pompeian styles demonstrate. Differences in the four styles are more related to structural and decorative ideas than to the style of the figurative painting, which is always rooted in Hellenism.

The Realistic Portraits of Fayium

In 1820, in the Oasis of Fayium west of the Nile Valley, a series of stuccoed wooden panels were discovered that featured realistic portraits painted in encaustic (medium in which the pigments are suspended in hot wax). The panels, which dated from the period between the first to fourth centuries, were funeral masks made by Greek and Roman artists.

These portraits, painted over a period of four hundred years, show many common elements such as an emphasis on huge, wide open eyes that had profoundly fixed stares, and on rotund outlines that combined an archaic hieratic expression with the realism of Roman portraits. The pictorial style of the Fayium influenced Paleo-Christian and Byzantine iconography.

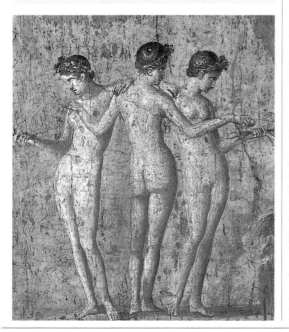

The Three Graces
(between the years 63 and 70).
Pompeian fresco unmistakably
inspired by a Greek model.
National Museum, Naples.

THE HELLENISTIC TRADITION IN EUROPE

Greek classicism and the later Hellenistic style had a huge impact on European art.
Many great works in the history of art can be clearly traced to Greek influences.
The aesthetic achievements in Greek culture have been (and continue to be)
present in European art, from Roman times and the rise of Christian art until our time.
This presence is evident in many different ways.

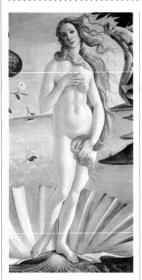

The Venus of Cnido
*(fourth century BC), right,
and Botticelli's* Venus
*(fifteenth century), above,
reveal the same classical intent
despite the centuries that
separate the two works.*

Permanence of Classicism as a Concept

Classical art works, understood as art achievements resulting from a search for perfection in the human body form and for beauty in all things, are a triumph of classical Greek aesthetic principles that have had a following of disciples throughout the history of art. As for the iconography of the human body, it is clear that nudes portrayed throughout the ages serve the sole purpose of eliciting an aesthetic, balanced, and serene emotional feeling, *independent of the work's message or intent and the author's style.*

In this sense, a Greek Venus is as classical as the nude in Botticelli's *Birth of Venus*, the nudes in many Renaissance and Baroque works, or the nudes in works by Ingres, Modigliani, and several contemporary artists.

Permanence of Poses

At times it seems that Hellenism depicted the human body in all of its possible poses. While this may be an exaggeration, the truth is that if we review figure

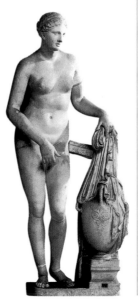

drawings and paintings after Hellenism, we find a series of poses, properly called classical, that are repeated in all periods as another legacy of Greek classicism.

The *contrapposto* (counterpoise), for example, is a very classical pose of standing figures. In this pose, all of the weight of the body rests on a straight leg, while the other leg is bent at the knee.

The contrapposto gives the body a sinuous quality, with the hip on the side of the planted leg thrust up and outward and the shoulder angled downward toward the side of the bent leg. We find a classical example of this pose in the *Aphrodite from Cyrene* dating to the end of the fourth century BC.

We also find contrapposto figures of varying artistic worth in Roman, Gothic, Renaissance, Neoclassical paintings and, generally, in paintings of all periods.

The same occurs with other less common poses. For example, when looking at the study of the female nude Delacroix painted in *The Death of Sardanapalus*, it is impossible not to recall Scopas' *Madwoman* (fourth century BC).

We can mention many other similar parallels without, however, implying that post-Hellenistic artists were motivated by a conscious effort to plagiarize. What happened is that Hellenism brought to an end one of the most fertile creation cycles in universal art in which everything, or almost everything, was tried and resolved.

Permanence of Themes

Greco-Roman mythology, with its enormous array of allegorical figures and legends that link Olympus with the human race, presented artists of all times with a broad range of themes for expressing their aesthetic ideas, that is, their style. Regardless of the reasons, it is clear that several classical themes hold a particular interest for artists and reappear in the work of major painters who belong to different periods and display different styles. The theme of The Three Graces, for example, treated in classical

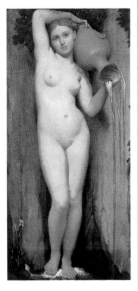

The Aphrodite of Cyrene *(fourth century BC), above, and Ingres'* Fountain *(nineteenth century), left. The classical contrapposto of the first work is reproduced in the second.*

antiquity, has been reinterpreted by such different artists as the German Hans Baldung (1484–1545), Raphael, and Rubens, to mention only a few.

Goya, too, was interested in themes from classical mythology, some of which he treated with great romantic feeling and extreme realism. We refer here to his *Saturn Devouring His Son*. In more recent times, we can also mention the special appeal that the *Legend of the Minotaur* held for Picasso who dedicated a good part of his graphic work to the subject.

Attraction and Permanence of the Styles of Classical Architecture

Greco-Roman architectural styles are apparent in the work of many painters who at various times achieved fame as being true specialists in the painting of "classical" ruins.

Raphael's The Three Graces. *Raphael and other artists can trace the origin of their Three Graces to the Hellenistic fresco depicting the same theme. See page 21.*

Main Ideas

• Western art is rooted in the aesthetic and technical achievements of Greco-Roman culture.
• All of Western culture has been endowed with artistic contributions derived from the classical legacy.
• Aesthetically and thematically, the classical tradition has been (and continues to be) preserved, influencing styles or modifying old artistic formulas inherited from Greece and Rome.

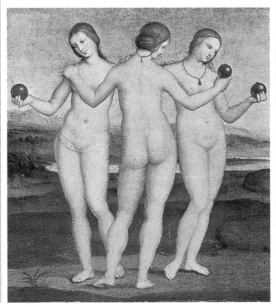

PALEO-CHRISTIAN, BYZANTINE, ROMANESQUE ART

Christian iconography traces its roots to the art displays in the Roman catacombs and to Byzantine art. In the West, it was the great monastic orders that safeguarded the Byzantine, Carolingian, and Ottonian iconographic traditions. There, the Romanesque style provided an aesthetic unity to Church art during the eleventh, twelfth, and thirteenth centuries.

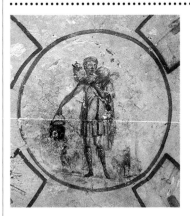

The Good Shepherd *(third century). Mural painting from the Catacombs of St. Calisto, Rome.*

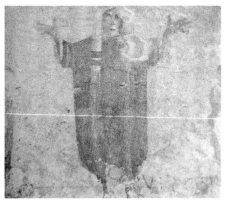

Figure of an orant. Mural painting from the Catacombs of Santa Pristila, Rome.

The Paleo-Christian Style

The art in the catacombs, which lacked tradition, began as a reinterpretation of pagan motifs, which were given new meaning. An example is the Hellenistic Calf-Bearer, which Christian iconography identifies with the Good Shepherd.

Paleo-Christian painting, characterized by simple outlines and few embellishments, created its own symbols and iconography. A common theme is the front view of a standing petitioner with outstretched and raised arms. The face is reminiscent of the Roman-Egyptian style found in the Fayium portraits.

The Style of Byzantine Painting

With the fall of the Western Roman Empire (476 AD), Byzantium remained for four centuries the only beacon of light recalling a lost splendor and a site from which a new Christian aesthetic

emerged. This period coincided with the time when mosaic artistry, which Byzantine artists mastered to perfection, reached its greatest technical skill. The material used in mosaics (colored mosaic tiles) lends itself to very synthetic drawings within contours delineated by dark borders. The tremendous chromatic impact of the mosaic and the fact that most mosaics were viewed

Main Ideas

- Paleo-Christian art, which initially drew on pagan iconography, created its own symbols and iconographic formulas.
- The first great Christian artistic tradition evolved in the Eastern Roman Empire or Byzantium, and propagated to the West where it merged with Romanesque aesthetic ideals.
- Romanesque painting is highly symbolic and it developed during the eleventh to the thirteenth centuries.

from a considerable distance, help in the visual synthesis of shapes.

The use of rich materials (gold, silver, mother-of-pearl, etc.) gave mosaics a dignified and sumptuous flair and a hieratic expression that mirrored the pomp and ostentation that surrounded the emperor and the new ecclesiastical hierarchy. *Movement and expressiveness disappear in the great Byzantine mosaics and are replaced by posturing.*

Illustrated Manuscripts

Byzantium's most individual and advanced artistic contribution lies in the illustration of manuscripts, which, though not uniform in style, had enormous influence on all aspects of Christian art. Depending on their origin, the manuscripts reveal either archaic traits or a clear effort to recapture a Hellenist style. The so-called *Codex Purpureus* (Diocesan Museum of Rossano, Italy) and the *Cotton Bible* (British

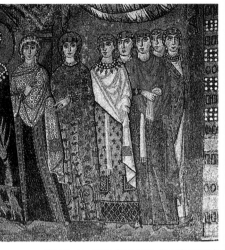

Theodora and Her Attendants. *Byzantine mosaic (sixth century) at San Vitale, Ravenna.*

Theodora and Her Attendants. *Detail of Theodora's head. The figure's synthetic impact when viewed from a distance disappears at close range.*

Museum), both dating from the sixth century, are respective examples of the two tendencies.

Icons

Icons are paintings done on portable supports whose most distant origins can be traced to Hellenistic and Roman easel paintings as well as to the Fayium portraits. Executed on wood in tempera or encaustic, the most luxurious icons were further enriched by substituting the paint with small mosaic tiles. Icons designed for use as imperial gifts were made even richer with precious metals and enamels. Their style combines the traits of mural painting and they most often depict the Pantocrator Christ and the Majestic Virgin.

The Romanesque Style. Principal Characteristics

The Romanesque period was laden with symbolism, its art reflecting little known philosophic and aesthetic ideas rooted in theology and a concept of beauty much different from the Greco-Roman ideal. Characteristic traits are:

• Romanesque painting has a profound theological meaning.
• Romanesque figures were never considered images of corporal beauty, but symbols of spiritual and eternal beauty.
• Romanesque painting has a didactic purpose; Romanesque murals were the "Bible of the poor."
• Mural painting was totally subordinated to architectural space, with the painted shapes

extending, shrinking, separating or combining, depending on the space they occupied.
• Figures are outlined through precise contours defined by dark lines of varying thickness. (1)
• Romanesque painters only worked with flat colors: white, black, reds, ochers, greens, and blues. (2)
• Chiaroscuro does not exist. It is suggested with parallel bands of different tones. (3)

Detail of The Wise Virgin *(circa 1100). Romanesque fresco from Sant Quirze de Pedret. Catalonia Museum of Art, Barcelona.*

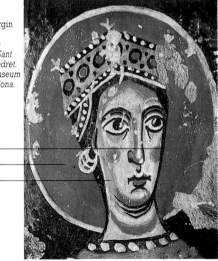

ROMANESQUE PAINTING (II)

The Great Themes of Romanesque Painting. The Pantocrator.

Romanesque painting developed its own unmistakable iconography. The Pantocrator of the twelfth century embodies the image which in the church's biblical tradition symbolizes the power of God. In the Romanesque apses, Christ is shown *seated on a throne, powerful and majestic*. His immense, synthetic figure, which transcends all human relevance, shows absolute symbolic determination—from the depiction of the features and the hair, to that of his right hand (*dextera Domini*), which blesses (or threatens) with the index, middle finger, and thumb extended in the trinity symbol. The left hand holds a book in which a sentence is written: *Ego sum lux mundi* (I am the light of the world) or *Hoc Deus, alpha et omega* (this God, alpha and omega, meaning I am the beginning and the end). With his feet supported on a stool or a globe symbolizing the Earth, the Almighty is enclosed by an almond-shaped halo surrounded by *tetramorphic figures*, symbol of the evangelists, who give glory, honor and thanks to *Him, Who is seated on the throne*.

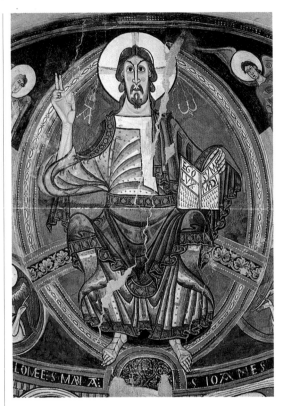

Pantocrator (1123).
Apse of Sant Climent de Taüll. Lleida. Catalonia Museum of Art, Barcelona.

The Virgin *Theotocos*

In the churches dedicated to Mary, the Pantocrator was substituted by an image of the Virgin, who symbolized the path to the *throne of Christ the Savior*. In a world in which the woman was held by the Church as a necessary evil, Mary is the *new Eve*, symbolized by an hieratic image that holds the Child Jesus, whose proportions and features seem more those of an adult: a small version of the Pantocrator.

Winged Figures

The winged Romanesque figures represent the angels, archangels, cherubim, and seraphim, meant to give glory to God and to be messengers between Him and mankind. They are human bodies with wings who, on occasion, lose part of their anthropomorphic appearance to take on some attribute that symbolizes a specific function in God's plans.

The Tetramorph

This is an eastern iconographic element, a chimerical animal with four (*tetra*) forms (*morphs*): human head, eagle wings, front feet of a lion, and back feet of a calf. This formula was adapted by the Romanesque artists to represent the four evangelists, each with a personal symbol: Matthew, man; Mark, lion; Luke, ox; and John, eagle.

The Human Figure

Romanesque religious painting portrays the human body without the least naturalist

Virgin with Child and Angels (*twelfth century*). *Board from Sant Martí Sescorts. Catalonia Museum of Art, Barcelona.*

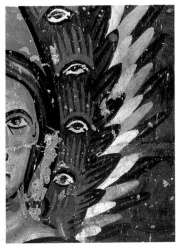

Cherubim of Santa María de Esterri d'Àneu *(twelfth century). Detail of the wings with heterotrophic eyes. Catalonia Museum of Art, Barcelona.*

Main Ideas

- Romanesque painting expresses theological ideas through symbols and characteristic iconographic formulas.
- The nude appears only in biblical accounts and displays unreal anatomical form derived more from the imagination than knowledge of anatomy.
- Only the Virgin, apostles, and saints are deemed worthy of being portrayed on the walls of churches.
- The Romanesque bestiary is full of fantastic creatures.
- Miniature illustrations represent the real Romanesque world.

concern and devoid of any physical appeal. The presence of a nude is justified only symbolically in stories such as the creation of man and his later fall.

The thirteenth-century mural from the Ermita de la Vera Cruz of Maderuelo, Segovia (today at the Prado Museum), is one of the best examples of the iconography of the Romanesque nude. This and other similar paintings are rendered with very sharp black borders and earth-colored internal lines that delineate anatomical areas unrealistically. These latter owe more to the artist's imagination than to actual knowledge of the human body, which points out the period's lack of interest in plastic beauty.

The Saints

The obsession with eternal damnation needed a "healing balm," a type of man (and woman) capable of becoming a

bridge between God and the world. This role was reserved for the apostles and the saints, especially the martyrs, worthy of being represented on the walls of the church either alone or as part of narrative sequences: the conversion of the saints, their struggle against the powers of evil (often represented by the reigning tyrant), their martyrdom, miracles, and glorification. What is surprising in these hagiographic stories is the realistic rendition of the martyrdom scenes, not because of the naturalism of the drawings which conform to Romanesque conventions, but because of their details.

The Romanesque Bestiary

Romanesque painters sought to display in their biblical scenes and symbolic representations, such as, for example, *The Lamb of God*, a knowledge of the familiar animal shapes they depicted. It

was, however, in their portrayals of monstrous animals that they showed their greatest fantasy and creativity. Bear in mind that in the eleventh and twelfth centuries, a monstrous element came to symbolize ugliness, a sight that could free man from his taste for the world of the senses.

Detail from the Martyrdom of St. Margaret. *Romanesque board from Sant Martí Sescorts. Catalonia Museum of Art, Barcelona.*

Miniatures

Miniature illustrations in Gospel books, prayer books, Psalm books, Chronicles, and so forth, by portraying concrete figures or events, reflect a naturalist criteria. Many other illustrated characters had no symbolic purpose, however, but were true graphic decorative motifs of the Romanesque world.

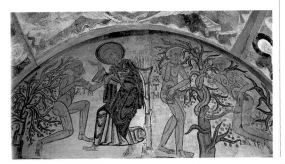

The Creation of Adam and Original Sin *(thirteenth century). Mural from the Ermita de la Vera Cruz of Mederuelo, Segovia. Prado Museum, Madrid.*

GOTHIC PAINTING

To understand the radical change that took place in Christian societies during the thirteenth, fourteenth, and fifteenth centuries, one only has to compare the head of a Pantocrator image of the twelfth century with the face on the image of the *Beau Dieu* in the Amiens Cathedral (dated between 1225 and 1235). The apocalyptic God of the Romanesque apses becomes, in Amiens, a "humanized" God who radiates peace and who wants to be loved more than feared. The Gothic artist came to realize that even great conceptualizations of God could be expressed through "human" images that were aesthetically pleasing. As a result, Gothic sculpture and painting acquired a more naturalistic character.

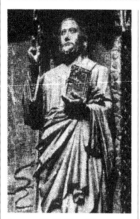

Image called Le Beau Dieu *from the Amiens Cathedral (thirteenth century).*

Gothic Stained Glass

It is not possible to understand Gothic painting without relating it to Gothic architecture. The genius of this architecture consisted in enabling buildings to rise vertically to great heights without relying on the support of thick walls. Enormous spaces became available between the support structures that sustained the buildings, allowing stained colored glass windows to replace painted murals.

The style of Gothic stained glass, which relied on a technique of leading, is reminiscent of the style of miniatures. It is, in other words, characterized by strong contours shaping the figures (consisting of the strips of lead holding the pieces of glass together), a profusion of blues and reds, scenes enclosed within medallions, ornamental arabesques, sets of ornamental curves, and reverse curves that connect different figures.

The Gothic Painting of Siena

Italian Gothic painting had a great impact on the style of painting in the rest of Europe. Outstanding artists, such as Duccio di Boninsegna, Simone Martini, and Lippo Memmi abandoned the

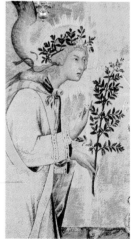

This detail of Simone Martini's Annunciation *(1333), Uffizi (Florence), reflects the characteristic traits of the Sienese School.*

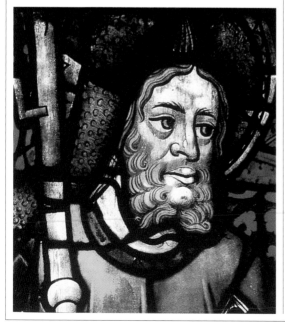

St. James. *Stained-glass fragment. Girona Cathedral.*

Byzantine style and, around 1308, embraced a new, profoundly lyrical style in painting spiritualized figures. The decorative element tended toward the arabesque and the figures showed formal influences from the Far East, particularly in the facial features and the hands. The faces displayed almond-shaped eyes, long, thin noses and very small mouths. The long, curved hands resembled the wings of a dove.

Florentine Gothic Painting. Giotto

Concurrent with the evolution of Sienese painting, Florence developed a mural painting style which, rather than lyrical, tended toward realistic humanism, attentive to expression and modeling. The greatest representative of this style of painting was the painter and architect Giotto di Bondone (1266–1334).

In his *Final Judgment* and in the fresco scenes from the life of Jesus at the Chapel of the Scrovegni (Padua), Giotto displays a volumetric and naturalist style that is close to real life. Giotto sought a return to the classical style by eliminating flat and golden altarpiece backgrounds for his figures. His characters do not just "exist," they also participate in the pictorial space with its mountains, buildings, and special perspectives.

Main Ideas

• Gothic architecture promoted the popularity of stained glass and altarpieces. Except in Italy, mural painting began to decline.
• Stained glass is stylistically related to the art of miniature illustration.
• The schools that most influenced Gothic painters were the Sienese School, with its Far Eastern tendencies and spiritualized figures, and the more volumetric and realistic Florentine School.
• The style for painting altarpieces follows the conventions of the large schools, from the Byzantine to the Renaissance School.

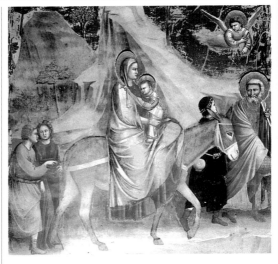

Sienese Painting Outside of Italy

Despite Giotto's tremendous influence on the artists of the *quattrocento*, the late Gothic was clearly dominated by the Sienese aesthetic, which reached truly remarkable levels of perfection outside of Italy. A good example is the Catalan painter Ferrer Bassa who gave us the mural decoration in the Chapel at Sant Miguel, at the Monastery of Pedralbes, Barcelona. These paintings, dedicated to the seven joys of the Virgin, followed the style of the Sienese School, particularly in the rendering of the Oriental features and of the hands resembling dove wings. Ferrer Bassa's originality is seen more in the colors and painting technique he used in these paintings than in his drawing ability. Reliable studies indicate the works were done in oil, a rare case in mural painting of the period.

The Altarpiece

The change in liturgical rites, whereby priests started celebrating Holy Mass with their backs turned toward the faithful, brought about the appearance of large

Giotto di Bondone.
Flight into Egypt. Fresco from
the Scrovegni Chapel, Padua.

altarpieces placed behind the altar (*retro tabulae*), a custom that persisted until the end of the Baroque period.

The main and lateral structures of the altarpiece were raised over a base or predella. The altarpiece was divided vertically into squares (separated by mullions or grooves between two moldings), subdivided, in turn, by arcs or canopies into ordinary spaces, a clear replica of the structure of Gothic architecture.

The altarpiece paintings followed the stylistic evolutions of mural painting: Sienese School, Florentine School, and later the Flemish and new Renaissance Schools.

Jaume Huguet (1415–1493).
Altarpiece of Saints Abdón and
Senén (figures of the saints).
Romanesque Church of Santa
Maria de Terrassa, Barcelona.

BETWEEN GOTHIC AND RENAISSANCE

At the beginning of the fifteenth century a new artistic trend evolved in Flanders that, without having direct links to Italian art, reached levels of perfection that have rarely been equaled. Flemish Gothic painting, with its taste for the medieval, delved deeply into the real nature of objects and people and influenced all of Gothic Europe. In addition to their aesthetic contributions, Flemish painters also introduced the use of oil in painting, which not only changed the way of painting but also the idea of what painting is.

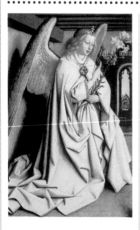

Jan van Eyck. The Angel of the Annunciation *from the Polyptych of the Mystical Lamb (finished in 1432). Cathedral at San Babón, Gante.*

The Master of Flémalle (Robert Campin, 1378–1444)

The Master of Flémalle is a painter who, with van Eyck, is credited with founding Flemish realism and inventing oil painting.

His works are more dramatic and fragmented than those of van Eyck. Sharp, incisive contours define the elements of his paintings, which are executed separately so that the total beauty of his compositions is the sum of their beautifully treated parts.

The favorite themes of the Master of Flémalle are interior scenes depicting bourgeois life, in which large windows, furniture, and other objects play a prominent part.

Master of Flémalle (Robert Campin). St. Barbara *from the Were triptych (1438). Prado Museum, Madrid.*

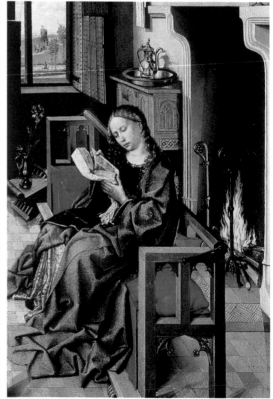

The van Eyck Brothers

Jan van Eyck was born around 1390 and died in Brussels in 1441. Like his brother Hubert who died in 1426, he was a sculptor. Both brothers, but especially Jan, are responsible for the greatest work of the Gothic-Flemish period, the *Polyptych of the Mystical Lamb*, an oil painting in which the treatment of shapes, color, and modeling reached a level of perfection that was unparalleled up to that time. Jan van Eyck introduced the realistic nude into painting, and was a poet of reality embodied in the smallest details. Each diadem or crown, flower, precious stone, is a small work of art perfectly executed and integrated into the whole of which it is a part. Van Eyck's artistic talent is particularly evident in his treatment of clothes. Genuine cascades of ample, heavy folds take on the appearance of a beautiful, monumental sculpture.

Rogier van der Weyden.
Descent from the Cross (1435).
Oil on board, 288 × 220 cm.
Prado Museum, Madrid.

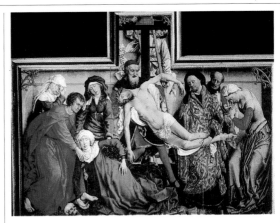

Rogier van der Weyden (1400–1464)

Van der Weyden is one of the greatest representatives of Flemish painting. His style combines the dramatic expression of the Master of Flémalle with van Eyck's feeling for sculpture and light, as seen in *Descent from the Cross*, a painting that dates from around 1435 and that is now found in the Prado Museum. This masterwork embodies all of van der Weyden's aesthetic ideas. The work is conceived formally and chromatically as an imposing sculpture-like group that should be viewed from the front. The drama unfolds in front of the golden wall of an architectural niche. The colored statuesque figures in the painting fill the space entirely and convey their human suffering, which is admirably expressed in unparalleled fashion by the plastic composition. The chromatic contrast between the ivory color of Christ's body and the blue of the Virgin's dress highlights the two parallel curvatures of both figures, focusing attention on them.

Flemish Painting in Europe

In Countries of Central Europe, the works of Moser, Witz, and Multscher demonstrate a profound assimilation of Flemish aesthetic ideals. In addition to being a sculptor, Hans Multscher (1400–1467) was a realist painter versed in the treatment of volumes, who was concerned with body and facial expressions.

In Germany, Flemish Gothicisim flourished until the end of the fifteenth century and produced a great artist in Michael Pacher (1435–1498), whose decorative style exhibits a taste for filigree and details and whose figures herald the arrival of the Renaissance.

In France, Provence produced works that synthesized Flemish style with French Gothic tradition and yielded artists such as the Master of Aix-en-Provence, Nicolás Froment (1435–1484), and the superb portrait painter Jean Fouquet (1425–1480).

In the Hispanic Kingdoms, Flemish painting became strongly rooted while preserving Sienese and Florentine influences. Painters like Lluís Dalmau and Bartolomé Vermejo upheld, with their great narrative paintings, the Flemish style in the Catalonia-Aragon kingdoms. Castille and Leon also produced distinguished artists such as the Castillian Fernando Gallego whose figures combine van Eyck's plasticity with the Gothic tradition of Castille and Leon.

Main Ideas

- During the fifteenth century, Flemish painting rivaled Italian painting.
- Without abandoning their Gothic roots, Flemish painters produced extraordinarily realistic and sculpturesque works.
- The Flemish style had enormous influence in Europe where it became firmly entrenched, with each country preserving the Gothic tradition.

Lluís Dalmau. Detail from the board La Verge dels Consellers *(1445). Catalonia Museum of Art, Barcelona.*

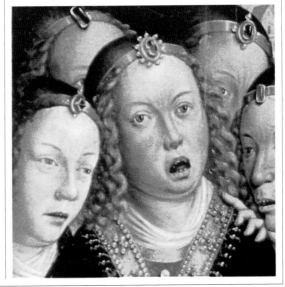

STYLES OF THE *QUATTROCENTO* OR EARLY RENAISSANCE

In fifteenth-century Italy, when Florence was governed by the Medici, a new style of painting emerged that broke with all past traditions. A renewed taste for classical antiquity revived interest in nature. The human body assumed normal proportions, the nude became an important topic in art, and landscapes were definitively incorporated into the painting. Perspective effects obtained through light and color became a challenge that was enthusiastically tackled by the artists of the *quattrocento*. Renaissance painting began with Fra Angelico, Masaccio, Paolo Uccello, and Filippo Lippi.

Fra Angelico, Bridge Between the Gothic and Renaissance

Fra Giovanni di Fiesole, better known as Fra Angelico (1387–1455), produced an extensive number of works on religious themes in which he combined medieval concepts with new Renaissance ideas. One can note a progressive move towards naturalism in the works of Fra Angelico, beginning with his *Triptych of St. Peter the Martyr* of 1425 and his *Annunciations* of 1430–1437, to his *Crucifixion and Saints* of 1441.

In his *Annunciation* at the Prado Museum, which dates between 1430 and 1435, the idealistic treatment of the Virgin and the Angel reflect a Gothic taste with clear influences by the Sienese School. Renaissance elements surface in Fra Angelico's organization of pictorial space, in the perspective of a portico and in the background elements. His *Garden of Eden* seems to be gleaned from a painting from Pompeii and the figures of Adam and Eve depict a "normal" man and woman in a naturalist style.

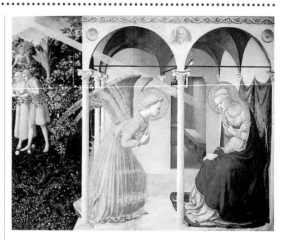

Fra Angelico, The Annunciation *(1430–1435), tempera on board, 194 × 194 cm. Prado Museum, Madrid.*

The Monumental and Naturalistic Style of Masaccio

Tommaso di Mone Cassai, known as Masaccio (1401–1428), is another Florentine who, despite his premature death between 1426 and 1428, engendered a renewal of Gothic painting. He discarded golden backgrounds in favor of landscapes, creating a pictorial space populated by realistic figures. His naturalism led him, at times, to discard in his paintings the golden halo that traditionally enshrines the head of saints, reducing them therefore to normal beings who don't inspire awe and are dressed in the day's fashion.

Masaccio's works also illustrate a thorough assimilation of perspective (*The Crucifixion*, in Santa Maria Novella, Florence), a monumentalism reminiscent of Roman art (*The Tribute Money*, in Santa Maria del Carmine, Florence), and the affirmation of the classical nude, as seen in his *The Expulsion from Paradise*.

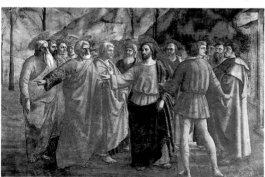

Masaccio. Main group from The Tribute Money *(1427). Fresco, 255 × 595 cm. Santa Maria del Carmine, Florence.*

Between Gothic and Renaissance
Styles of the *Quattrocento*
Towards the Height of the Renaissance

33

The Volumetric Style of Paolo Uccello

Paolo di Dono (1397–1475), known as Paolo Uccello, began his career as a sculptor and a disciple of Donatello, a fact evidenced by his strong preoccupation with volumetric space. Paolo Uccello's style relies on perspective, not as geometric discipline but as the art of assembling and organizing three-dimensional volumes in perspective, which explains his fondness for foreshortened figures.

Uccello's figures are solid, unemotional, and expressionless, placed in an artificial space that leads to rather ingenious solutions for shape configurations. We can appreciate this in his painting *Saint George and the Dragon* (National Gallery, London), which seems to be a mere excuse for creating a pronounced foreshortening in the saint's horse. This most characteristic feature of Uccello's works can be found in the three soffits depicting the *Battle of San Roman*, which he produced for the Medici palace. Helter-skelter groups of horses and knights drawn in the artist's characteristically rigid style and set around enormous spears and banners, demonstrate Uccello's mastery of the art of foreshortening and of reproducing objects such as steel, feathers, and brocades.

The Elegant Style of Filippo Lippi

Filippo Lippi, a religious brother from the Carmine Convent in Florence, began his artistic career in the vigorous style of Masaccio and ended it with the lyricism of Botticelli. Light and

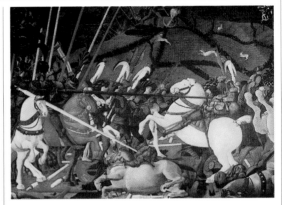

Paolo Uccello. The Battle of San Roman *(1451–1475), soffit from the Uffizi, 323 × 182 cm, Florence. Tempera on board. The most important work of Uccello, who was known for his volumetric compositions in three-dimensional space.*

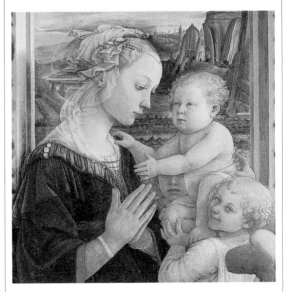

Filippo Lippi. Detail of Virgin with Child and Two Angels *(1465). Tempera on board, 63.5 × 92 cm. Uffizi, Florence.*

line are the two plastic elements that dominate Filippo Lippi's work, both in complex works such as the *Coronation of the Virgin* (Uffizi in Florence), as well as in minor works such as the *Virgin with Child and Two Angels* in which the Virgin's face is that of his mistress Lucretia Buti. The hair and face features, the exquisite transparencies of the fine sheer net and other details always are extraordinarily elegant. Lippi also produced great imaginary landscapes.

Main Ideas

- During the first half of the fifteenth century, Florentine painting abandons the Gothic tradition and signals the onset of the Renaissance period.
- The first theoretical art principles appear in the first half of the Italian *quattrocento* and in-depth studies are conducted on the human body, light, and color.
- The most noteworthy painters around 1450–1460 are Fra Angelico, Masaccio, Paolo Uccello, and Filippo Lippi.

TOWARDS THE HEIGHT OF THE RENAISSANCE

At the beginning of the second half of the fifteenth century, Italian painting completely abandons the conventions of the Gothic style. It moves decisively towards realistic naturalism, relying on perspective in the construction of pictorial space.
The tendencies that we note in the works of Masaccio and Filippo Lippi (volumetric and linear painting) are preserved until the end of the *quattrocento*. They are also evident in a long list of important painters, of whom, because of space limitations, we will mention only four.

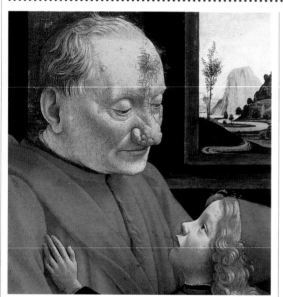

Mantegna. A Style Born from Donatello and from the Classic Past

Andrea Mantegna (1431–1506) is one of the quintessential Renaissance painters of the *quattrocento*. A lover of antiquity, and enthusiastic admirer of the sculptor Donatello, Mantegna places his Donatellian, sculpture-like figures in imaginary landscapes or classical "architectural edifices." This technique can be observed in his *St. Sebastian*, as well as his boards of *St. Peter and St. Paul*, and *St. Lorenzo* and *St. John* in Verona.

Mantegna is also noted for his penchant for details and daring foreshortenings. His famous *Dead Christ* is one of the most impressive foreshortened figures of all times, and one of the most moving representations of the Crucifixion.

The Realistic and Narrative Style of Domenico Ghirlandaio

Domenico di Tommaso Bigordi, known as Ghirlandaio (1425–1499), produced important stylistically eclectic narrative works. He models his figures with a sculpture-like plasticity and uses line contours to highlight profiles, to define features, and to work on details. His penchant for detail and for realism characterize both his narrative works (*Birth of the Virgin*, for example) and his portraits.

An excellent example of Ghirlandaio's almost Flemish realism is evident in his oil board *An Old Man and His Grandson*.

Domenico Ghirlandaio.
An Old Man and His Grandson
*(1480–1490). Oil on board,
62 × 64 cm. Louvre Museum, Paris.*

Andrea Mantegna. Dead Christ
(1470–1480). Oil on canvas, 81 × 66 cm. Pinacotecha de Brera, Milan.

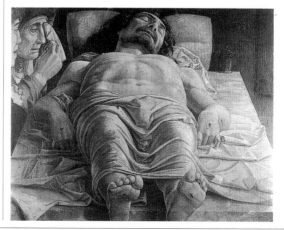

Styles of the *Quattrocento*
Towards the Height of the Renaissance
Styles of Italian Painting of the *Cinquecento*

35

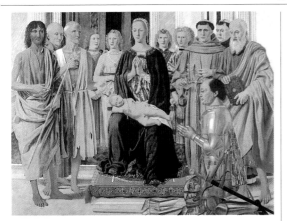

Piero della Francesca. Virgin with Child, with Angels, Saints and the Duke of Montefeltro *(1472–1474). Oil on board, 170 × 248 cm. Pinacotecha of Brera, Milan.*

The Luminous Style of Piero della Francesca

Pioneer of the so-called Umbrian School, della Francesca (1415?–1492) was the *quattrocento* painter most interested in light effects. There are no dramatic tonal contrasts in his frescoes or oil boards. Rather, one observes a bath of light that invades the entire pictorial space and illuminates each figure in the composition, from their faces and bare body parts to the deepest wrinkle. Della Francesca's most representative frescoes are the episodes of the *Legend of the Holy Cross* in the church of Saint Francis of Arezzo. His most representative oil board is perhaps the *Virgin with Child, Angels, Saints and the Duke of Montefeltro.*

The Melancholic Style of Sandro Botticelli

The pictorial world of Botticelli (1445–1510) is much more poetic than naturalistic. Showing greater interest in drawing and rhythmic pose than in modeling, Botticelli's

Sandro Botticelli. Spring, Group of the Three Graces *(1480–1481). Tempera on board, 314 × 203 cm. Uffizi, Florence.*

figures have gently tilted heads and lithe bodies whose limber poses are carefully delineated.

After producing large religious works in this style, Botticelli painted his profane compositions inspired by classical mythology: *Spring* (1480–1481) and *The Birth of Venus* (1485). Botticelli's style is fully embodied in these works: elongated and supple female bodies, clothing and veils that

Main Ideas

- The second half of the Italian *quattrocento* was completely devoid of Gothic influences.
- The painters swayed between a taste for sculpture-like plasticity and a more contoured, rhythmic tendency.
- The works of Ghirlandaio and Mantegna reflect a sculpture-like tendency; those of Botticelli, a linear tendency.
- Piero della Francesca introduced a luminous quality in the paintings of the first Renaissance that heralded the pictorial qualities that were synthesized in the paintings of the *cinquecento*.

blow in the wind, long locks of hair cascading in unusual arabesque designs; bodies that seem to dance on top of the ground rather than stand on it. All of this is painted in sober colors and executed with great plasticity in a most tender way.

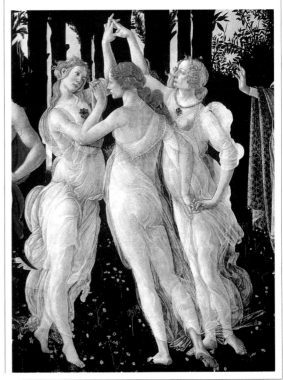

STYLES OF ITALIAN PAINTING OF THE *CINQUECENTO*

The gradual drift to naturalism by Italian painters of the *quattrocento* and the progressive influence exerted by art theory peaked in the sixteenth century. At the same time, historical circumstances shifted the center of the Renaissance from Florence to Rome where da Vinci, Raphael, and Michelangelo carried on the tradition of a new classicism under papal patronage.

The *Sfumato* (Shading) of Leonardo da Vinci

Leonardo da Vinci (1452–1519), a true Renaissance man who pursued all areas of knowledge, is one of the geniuses of universal art. A student of anatomy and perspective and an experimenter in painting, da Vinci believed that drawing was the basis for all plastic arts. He was a great master of *sfumato* (toning colors through shading), a technique that characterizes his wonderful drawings and paintings, such as *St. John* and the famous *Gioconda* or *Mona Lisa*.

In his *Last Supper* (at the Sta Maria delle Grazie convent, Milan), Leonardo shows his mastery in the treatment of pictorial composition and light effects. The frontal and background lighting dramatize the figures of Christ and the Apostles who, in groups of three, display alternating hand and face poses as they ask who the traitor is.

The Renaissance Classicism of Raphael

Raphael Sanzio (1483–1520), who was born in Urbino and died

Leonardo da Vinci. St. John the Baptist (1513–1516). Oil on board, 57 × 69 cm. Louvre Museum, Paris. Together with his Mona Lisa, Leonardo's St. John is the finest illustration of the artist's sfumato technique and smiling figures.

in Rome, epitomizes the classicism of Italian Renaissance.

His short, prolific life can be divided into three periods.

First period: Urbino, until 1504. One of the outstanding works of this period is Raphael's oil board *The Betrothal of the Virgin*. This painting, which was influenced by Perugino and Bramante and is a precursor to his later style, is characterized by luminosity, supple figures in relaxed poses, and a grouping of figures whose heads lie on the same plane (isocephalic plane).

Second period: Florence 1505–1508. Raphael assimilates Leonardo's *sfumato* and rich colors in compositions that are highly dynamic and pyramidal in structure, with inner details that display rounded rhythms. Some of Raphael's most beautiful Madonnas and Holy Families were produced during this period, as were some of his best portraits.

Third period: Rome 1509–1520. Large frescoes, such as *The Triumph of the Eucharist*, *The Athens' School*, *The Expulsion of Holiodorus*, and *The Liberation of Saint Peter*, from the so-called "sequences" represent the culmination of Raphael's art. These works are characterized by the accurate depiction of their fantastic architectural structures, their impeccably rendered foreshortened figures, and their treatment of light and color featuring an infinity of shades within the structure of the paintings.

The Hall of Psyche in the Villa Farnese, contains the best of Raphael's profane works. Wonderful sensual female nudes, subtle colors, and rhythmic compositions signal the triumph of the *grand manner* of painting that Michelangelo will later adopt.

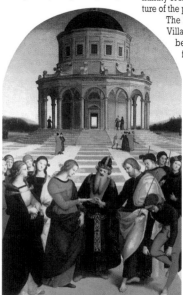

Raphael Sanzio. The Betrothal of the Virgin (1504). Oil on board, 117 × 170 cm. Pinacotecha of Brera, Milan. In this board, Raphael sets forth the compositional notion of an isocephalic plane.

Towards the Height of the Renaissance
Styles of Italian Painting of the *Cinquecento*
The Mannerist Style

37

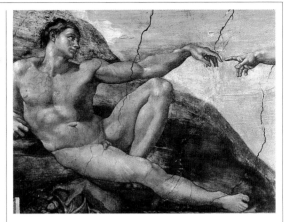

Michelangelo. The Creation of Adam *(1511–1512), fragment. Fresco painting, 570 × 280 cm. Ceiling of the Sistine Chapel, Vatican. The figure of Adam at the moment of receiving the spark of life through his Creator's finger is one of the most beautiful nudes in all of art history.*

The Grandiose Style of Michelangelo

Michelangelo Buonarroti (1475–1564) who, as he himself stated, was not particularly interested in color, knew how to use a brush to express himself in the same grandiose style that set him apart as a sculptor.

Michelangelo's pictorial style is defined in his *Holy Family*, (Uffizi Museum) 1503–1504. The roundness of the bodies and the pent-up energy evident in their poses hint at the Michelangelo of the Vatican paintings.

Michelangelo's extraordinary artistic power is splendidly reflected in his frescoes in the Sistine Chapel. Prophets, sibyls, and other figures from the Old Testament make up the figures whose poses, movements, and sculpture-like forms constitute a true apotheosis of the human body. The figure of Adam at the moment of receiving the spark of life through his Creator's finger is one of the most beautiful nudes in all of art history. And there is the impressive colophon scene of the *Last Judgment* in which about 400 full-bodied nude figures are depicted in every imaginable pose.

Venetian Classicism. Titian

Titian Vecellio (1487?–1576) is the greatest representative of the Venetian Renaissance. More interested in painting than drawing, Titian did not paint what he drew, but rather he drew as he painted.

His style included the use of diluted colors and a strong predilection for markedly Renaissance scenes and figures, like, for example, his *Venus of Urbino*, which is at the Della Rovere palace. Other nudes, which feature a classical sensuality and ivory-like quality (*Danae*, the nudes of the *Bacchanal*, *Venus Enjoying Love and Music*), share the spotlight with characters from his native Venice.

In his religious works, Titian relies on the same *grand manner* style that characterizes Michelangelo's work, without forsaking his preference for painting oil canvases and producing very large compositions such as his *Assumption of the Virgin* (360 × 690 cm).

Titian Vecellio. The Bacchanal *(1518–1519), fragment. Oil on canvas, 153 × 175 cm. Prado Museum, Madrid. Titian's nudes feature a classical sensuality and ivory-like quality of skin tones.*

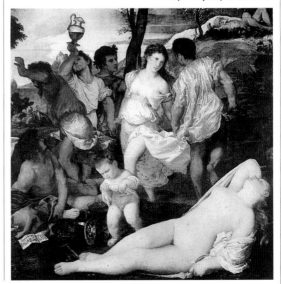

Main Ideas

• Italian Renaissance painting reaches its classical peak during the *cinquecento* and gives rise to Mannerism, which exerted international influence and is characterized by a high degree of creativity.
• The masters who launched the *grand manner* painting style are Leonardo da Vinci, Raphael Sanzio, and Michelangelo Buonarroti in Rome, and Titian in Venice.

THE MANNERIST STYLE

With Michelangelo, the style of painting shifted to new and more dynamic forms, distancing itself from the balance and equilibrium of classicism. The style that emerged, which came to be known as Mannerism, was followed by the disciples of Raphael and Michelangelo who continued to paint in the great mannerist style of their masters. Mannerism is not synonymous with mannered and is not a consistently uniform style, although its disciples share common characteristics: a taste for detail, dynamic forms, depiction of luxurious clothing, and highly magnificent architectural spaces.

The Italian mannerists make up a long list of great painters: Andrea del Sarto, Pontormo, Bronzino, Giulio Romano, Sebastiano del Piombo, Correggio, Vasari. Tintoretto and Paolo Veronese are the style's most distinguished representatives.

Tintoretto

Jacobo Robusti (Venice 1518–1594), known as *Il Tintoretto* because he was the son of a cloth dyer, studied with Titian for a short time. Influenced also by Michelangelo, he acquired a style that is outstanding for its fiery dynamism (he was called *The Madman*) and vigorous chromaticism. He loved to paint in his studio by lamp and torch light and many of his paintings portray night scenes.

His paintings are characterized by asymmetrical compositions in which the protagonist is cleverly offset with respect to other assembled figures. In *The Washing of the Feet*, for example, the figures of Jesus and Peter form a group at the extreme right of the composition, with the other figures distributed throughout the pictorial space. In the brilliantly composed *Last Supper*, his final work, the light emanating from the figure of Jesus and from a ceiling lamp provides contrasts and background lighting that breaks up the darkness and gives the picture a phantasmagoric and shadowy ambiance.

Elongated figures, flexed bodies, shapes that are barely sketched next to others that are highly detailed, color contrasts and violent lighting, reveal pictorial expressions that recall El Greco. Besides his great religious works, Tintoretto painted female nudes (*Susana and the Old Men*) that are precursors to the excesses of the Baroque.

Jacopo Robusti, Tintoretto, The Last Supper (1592–1594), fragment. Oil on canvas, 568 × 365 cm. Church of San Giorgio Maggiore, Venice. In this highly original rendition of the Last Supper, Tintoretto's stylistic traits will appear in El Greco works.

Paolo Veronese

Paolo Caliari Veronese (Verona, 1528; Rome, 1578), is a painter of grandiose scenes and sumptuous colonnades. The figures are often portraits of contemporary people richly attired. Veronese covers them in opulent apparel (at times Oriental) that he accentuates through the use of pasty paints that highlight the shine of satins and brocades. All this he does without the least concern for historical accuracy. In *Moses Saved from the Waters of the Nile*, the artist turns the pharaoh's daughter into a Venetian duchess luxuriously dressed in a manner befitting her status. And when painting his huge work *Marriage*

at Cana (990 × 669 cm), he does not hesitate to turn the Bible story into a lavish Venetian party taking place in a Renaissance architectural setting with a group of Renaissance musicians providing

Paolo Caliari, Veronese. Marriage at Cana (1562–1563), detail. Oil on canvas. Louvre Museum, Paris. Veronese's attempt to bring up to date historical scenes leads him to include a group of Baroque musicians in a biblical scene.

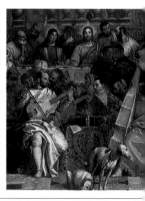

entertainment. In his other large mural, *Dinner at the Home of Levi* (1,280 × 555 cm), the characters appear to shrink beneath a monumental loggia, under which the banquet takes place.

It is characteristic of Veronese's technique to paint upward perspectives (*sotto in sú*), thereby foreshortening the groupings of figures in the foreground. This characteristic is evident in his *Allegory of Love* at the National Gallery, and in *Jesus Among the Doctors of the Temple*, at the Prado Museum.

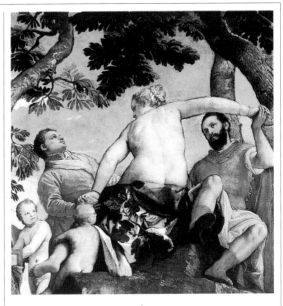

Paolo Caliari, Veronese. Allegory of Love. *Oil on canvas, National Gallery, London. The upward perspective in many Veronese paintings (*sotto in sú) forced him to portray foreshortened figures.

Main Ideas

• Mannerism is the aesthetic current that continues Raphael's and Michelangelo's tradition of *grand manner*.
• Venetian Mannerism, represented especially by Tintoretto and Veronese, showed a predilection for large, crowded compositions that reflected the wealth of Venetian society during the second half of the sixteenth century.
• Among non-Italian Mannerists, the genius of the Spaniard El Greco stands out as the greatest representative of pictorial mysticism.

Doménikos Theotokópoulos, El Greco (1541–1614)

Italian mannerism influenced artists throughout Europe who, like El Greco, knew how to give a nationalistic flavor to their paintings.

Although he was born in Crete, El Greco is considered a Spanish painter from Toledo, the city where he settled after spending time in Venice and Rome where he was influenced by Titian and Tintoretto. From Titian he assimilated the use of diluted colors and

from Tintoretto the elongated figures and the skill for chromatic contrasts that, though often violent, found vindication in the harmony of the painting. This trait is highlighted in Christ's crimson tunic in *The Expolio* (Toledo Cathedral) and in the extraordinary yellows in the *Burial of Count Orgaz* (Church of Saint Tomé,

Toledo). But it is El Greco's mysticism, alive in the large, moist eyes of Christ in *The Expolio* that enables him to transcend reason and to produce, in his final period, bold works that have the earmarks of modern painting: *View from Toledo*, *The Visitation*, *The Assumption*, and *Laoconte and His Sons*.

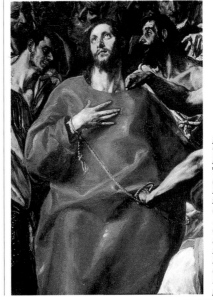

Doménikos Theotokópoulos, El Greco. The Expolio (1577–1579). *Detail from the figure of Christ. Oil on wall panel, 173 × 285 cm. Christ's large and moist eyes represent the best expression of mysticism in El Greco's paintings.*

THE RENAISSANCE OUTSIDE OF ITALY

The tremendous admiration that da Vinci, Raphael, Michelangelo, and Titian inspired, as well as the presence of Italian and Flemish artists in European courts, gave considerable stylistic uniformity to the Renaissance movement outside of Italy.

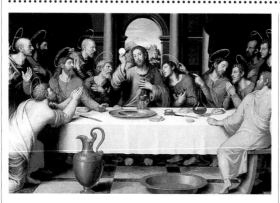

Juan de Juanes. The Last Supper (about 1570). Oil on board, 191 × 116 cm. Prado Museum, Madrid.

The Spanish Renaissance

Valencian Renaissance Painting produced, among others, artists like Juan de Juanes (1523?–1579) whose works, *The Mystical Betrothal of the Venerable Agnesio with Saint Inés* and *The Last Supper* (Prado Museum), were greatly admired. These works are reminiscent of da Vinci in their treatment of light, and of Raphael in their drawing and color techniques.

Castillian Renaissance Painting was centered principally in Valladolid. Its most noteworthy representative was Alonso de Berruguete, who was also a great sculptor. His paintings exhibit a range of gray, red, and blue tones that the artist used to create light effects on figures in expressive poses.

The Andalusian Renaissance was centered in Granada and Seville. Raphaelism predominated in both cities thanks to the works of Pedro Machuca and Pedro de Campaña, masters of chiaroscuro and of light effects as their *Descents from the Cross* show. Luis de Vargas (1506–1568), painter of exalted Mannerism, painted in the same vein, as seen in his works *The Birth* and *The Temporal Generation of Christ*, known as *"La Gamba"* in the Cathedral of Seville.

The French Renaissance

The French Renaissance developed under the influence of great Flemish and Italian masters, such as da Vinci and Andrea del Sarto, who were in the service of Francis I.

Several Italian Mannerists (Rosso, Niccoló dell'Abbate, Primaticcio) were called upon to decorate the Palace at Fontainebleau. Their contribution resulted in a flourishing of painting of

Luís de Vargas. The Temporal Generation of Christ (La Gamba, 1561). Oil on board, 175 × 183 cm. Seville Cathedral.

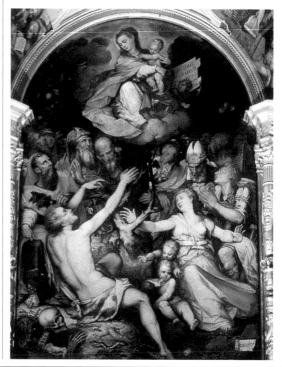

nudes, a trend that was embraced by French painters. Standing out is the example of *Diana the Huntress* (anonymous), and *Eva Prima Pandora*, a Raphaelist nude of rare symbolism by the multitalented artist Jean Cousin (1490–1560).

Portrait painting was in great demand during the French Renaissance, with Jean Clouet (1485–1540) and his son Françoise (1505–1572) standing out among artists for their technique and realistic qualities. With the precision of a Flemish portrait artist, they applied oil colors in Italian chromatic style to a penciled sketch. Outstanding are their portraits of *Francis I* and *Isabel of Austria* rendered with exquisite precision and imbued with an air of melancholy.

The German Renaissance

Despite a strong Italian influence, the Gothic tradition and Flemish influence kept the German Renaissance detached from the classicism of Raphael and the Mannerism of Michelangelo.

Albrecht Dürer (1471–1528) is the leading representative of German Renaissance. A humanist, student, and researcher of

aesthetic theories, his style produced dynamic figures imbued with classicism, as can be seen when comparing his engraving of *Adam and Eve* (1504) with the haughty nudes in his oil *Adam and Eve* (1507) at the Prado Museum. The figures in the first work, depicted in a rigid contrapposto stance, give way to the rhythmic and dynamic poses of the lithe bodies in the second work. In this latter work, the narrative is simply a pretext for the search for beauty in the two human bodies.

The son of a goldsmith, he learned the trade from his father, which explains his solid and plastic approach to details (self-portraits, watercolors of plants and animals), as well as his amazing mastery of engraving to which he owes a good part of his fame. Examples are his xylographs on *The Apocalypse* and his engravings *The Knight* and *Death and the Devil* of 1513.

The Italian influence is most evident in his works *The Adoration of the Magi*, 1504 (Uffizi, Florence) and *The Holy Trinity*, 1511 (Vienna), in which Dürer treats pictorial space in a way reminiscent of that of Raphael.

Hans Hoblein the Younger (1497–1543) is one of the great German painters of the sixteenth century. A renowned portrait

artist, his works display remarkable precision of details to which he assigns the same importance as to the subject of the painting. In his portrait of *Nicholas Kratzer*, for example, the scientific instruments are rendered with extraordinary authenticity and realism and help to define the scientific personality of figure.

Jean Clouet. Portrait of Francis I *(1525–1530). Oil on board, 73 × 96 cm. Louvre Museum, Paris.*

Albrecht Dürer. Adam and Eve (1507). *Oil on board, 83 × 209 cm. each soffit. Prado Museum, Madrid.*

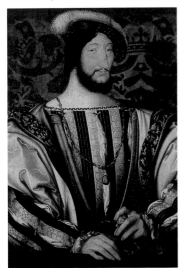

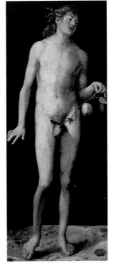

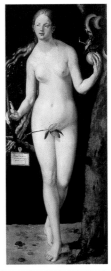

THE RENAISSANCE IN THE NETHERLANDS

The strong political upheavals that occurred in the Netherlands during the sixteenth century hindered the development of artistic activities by Dutch and Flemish painters. Furthermore, in those cities where the artistic level had peaked during the fifteenth century, artists were reluctant to change strongly consolidated aesthetic ideals. As a result, the Renaissance arrived late in Flanders and Holland and was adapted to conform with traditional tastes imbued with a Gothic flavor.

Quentin Matsys. The Banker and His Wife *(1514). Oil on board. Louvre Museum, Paris.*

Matsys and Patinier

Flemish painting during the transition from the fifteenth to the sixteenth century, is, in many respects, a continuation—not a break—of the grand school of painters who produced realistic and luminous oil paintings.

Quentin Matsys (1465–1530) is one of the artists who characterizes the transition. His paintings of interior scenes, with their Gothic features and da Vinci influences, make an important humanistic contribution that anticipates the later works of Vermeer.

Joachim Patinier (1480–1524) was a painter of religious themes whose main figures preserve a late Gothic flavor, including the studied plasticity of the draped folds in the clothing. In reality, however, his themes are a pretext for conceiving broad spaces filled with peasants and animals, and for including characters who give the paintings their titles.

The Work of Hieronymus Bosch

Hieronymus Bosch (1450–1516) was born in Bois-le-Duc, a town located north of Brabant. As undoubtedly one of the most amazing artists in the history of art, his works are difficult to classify.

His compositional ideas and the inclusion of folkloric elements, executed with realism

and a keen sense of irony and sarcasm, distinguish his works from others in the period.

One need only compare his masterpiece, *Garden of Earthly Delights* that is contemporary with many Raphael frescoes, to understand how Bosch's ideas are much closer to expressionism and surrealism than to the classical style of the Renaissance.

However, in spite of everything, Flemish tradition permeates Bosch's works and provides a

mysterious allure to his original themes:

In *Ship of Fools* and *Curing Folly* he ridicules what then passed for science and its followers.

The Haycart is a discursive and symbolic work that illustrates the Flemish proverb: "The world is a mountain of hay and men want to get as much of it as possible."

Garden of Earthly Delights is a completely surrealistic work, full of animal-like characters and unreal dream-like objects and

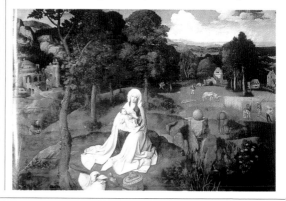

Joachim Patinier. Rest on the Flight into Egypt. *Oil on board, 177 × 121 cm. Prado Museum, Madrid.*

structures. While amusing the viewer with its realistic qualities and easy composition, the work also includes elements that can be repugnant.

Pieter Bruegel the Elder (1525–1569)

Bruegel the Elder is a painter of nature of which man is an integral part. His paintings are, for the most part, an art chronicle of his rural world with its landscapes and people. His works are characterized by a strong plastic quality, realistic and detailed studies, perfect perspective, and a broad range of luminous colors.

His work, the *Parable of the Blind*, reveals the painter's penchant for depicting regional customs and details in the pathetic figures drawn with extraordinary precision and painted with luminous, almost transparent, colors.

The Peasant Dance is a magnificent atmosphere piece in which Bruegel displays his mastery of composition, chiaroscuro and chromatic contrast, and his encompassing pictorial vision while preserving, at the same time, the details that describe a society and its customs.

Triumph of Death is a work of clear rhetorical (rather than romantic) character. It depicts a nightmare landscape, a theme popular with several metaphysical and surrealist artists of the twentieth century, and is filled with an odd assortment of ghostly beings involved in activities associated with the kingdom of death.

Hieronymus Bosch.
Allegory of The Haycart.
Detail on the central soffit.
Oil on board, 100 × 135 cm.
Prado Museum, Madrid.

The Hunters in the Snow, The Fall of Ikarus, The Massacre of Innocents, and *The Harvest* are rendered in the same style.

Main Ideas

• The high artistic level achieved in the sixteenth century by painters of the late Flemish Gothic period in the Netherlands explains their reluctance to adopt the new Italian style.
• Matsys's portraits and interior scenes, and Patinier's landscapes depicting biblical and religious scenes, are the most important works of the Flemish transition period.
• Hieronymus Bosch is one of the most original painters of all times, a forerunner of expressionism and surrealism, who maintains, at the same time, a Gothic spirituality.
• Bruegel the Elder is the greatest representative of Flemish folklore in his realistic depiction of regional customs and the Flemish landscape.

Pieter Bruegel the Elder.
Parable of the Blind *(1568).*
Tempera on canvas, 154 × 86 cm.
National Museum of Capodimonte, Naples.

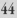

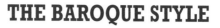

THE BAROQUE STYLE

As we mentioned before, the Baroque tendency emerges when the balance between shape and movement tilts in favor of the latter. In this sense, the Baroque tendency is not restricted to any given period. However, the historical Baroque, which spans the period from Caravaggio until well into the eighteenth century, originated from the evolution of Mannerism towards aesthetic criteria that emphasized superabundant and pompous shapes and which became dominant in all of Europe.

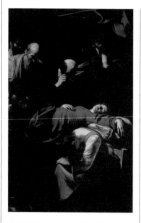

Caravaggio, The Death of the Virgin *(1650), fragment. Oil on canvas, 245 × 369 cm. Louvre Museum, Paris.*

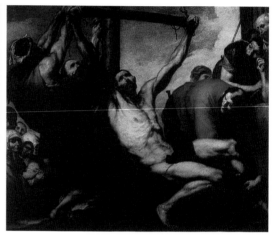

José Ribera, Il Spagnoletto, St. Philip, Martyr *(1639). Oil on canvas, 234 × 234 cm. Prado Museum, Madrid.*

Caravaggio and *Tenebrism*

Michelangelo Merisi (1573–1610), called Caravaggio after the town where he was born, is the most important painter of the transition between the sixteenth and seventeenth century and the originator of *tenebrism*, a technique in which the interplay of light and shade is used to accentuate forms.

In Caravaggio, lateral light invades space in such a way that forms are shaped by violent contrasts. However, Caravaggio's figures are characterized by an extreme realism, a faithful interpretation of the original model regardless of the subject depicted. *Caravaggio establishes a bridge between ideated and perceived forms.*

His formal realism often displeased the Church, which rejected one of the most extraordinary paintings of all times, his *Death of*

the Virgin, as being "too human." Lacking heavenly apotheosis, and with the Virgin and Apostles depicted as ordinary people, the only mystery in this work is provided by its light, color, and an amazing expressiveness.

Other Important *Tenebrist* Artists

José Ribera (1591–1652), known in Italy as *Il Spagnoletto* (The Little Spaniard), was born in Valencia and died in Naples where he spent almost his entire life. He is one of the greatest Baroque painters of religious themes. Ribera's paintings, with their unadorned and realistic plastic expression, had an enormous impact not so much for their plays of light and shade as for the spectacular nature of their foreshortened figures and twisted poses.

One of his most clearly Caravaggian works is his *St. Andrew*, on display at the Prado Museum.

The *Tenebrism* of George de la Tour

The few works of George de la Tour (1593–1652) were forgotten for a long time, and it was only beginning in 1914 that his works have received their deserved acclaim.

The source of light in de la Tour's *tenebrism*, whether a candle or a torch, is visibly displayed within the scene and the painting's light and shade effects are developed based on the light's position with respect to the figures. The candlelight hardens the features, unifies the color, and flattens the volumes, while bestowing on the scene an essential realism devoid of extras, landscapes, or architectural structures.

The Carraci Brothers

A more idealistic, dynamic, and decorative Baroque style started in Bologna, influenced by

Georges de la Tour. St. Joseph the Carpenter *(about 1640).*
Oil on canvas, 100 × 137 cm.
Louvre Museum, Paris.

Annibale Carracci. The Triumph of Bacchus *(1597–1600).*
Fresco painting in the vaulted dome of the Farnese Palace, Rome.

the Carraci brothers (Ludovico, Agostino, and Annibale) who are the founders of what is considered the first modern school of fine arts. This style became known as the Eclectic Baroque.

Annibale Carraci (1560–1609) endeavored to synthesize in his personal style the formal purity of Raphael with the colors of Titian and Veronese. His eclecticism can be seen in his frescoes in the great gallery of the Farnese Palace that are full of light and movement, in his religious works in which he does not renounce *tenebrism,* and in his paintings *Venus and Adonis* and *Venus and the Satyr.*

The Venetian Baroque

Giambattista Tiépolo and Canaletto, both painters of the so-called Venetian School, are among the outstanding artists of the Italian Baroque period of the eighteenth century.

Tiépolo (1696–1770) is a great master of fresco painting. His frescoes, bathed in cerulean lights, are technically perfect and display a highly personal style. Creating scenes viewed from astounding angles, he constructs inverted perspectives and incredible foreshortenings

Giambattista Tiépolo. Apotheosis of the Spanish monarchy *(fragment). Fresco painting at the Royal Palace, Madrid.*

Antonio Canal, Canaletto.
La riva degli Schiavoni *(detail).*
Oil on canvas, 46 × 62.5 cm.
History of Art Museum, Vienna.

in which the characters seem to emerge from clouds or float in the air.

Antonio Canale, Canaletto (1697–1768) is the painter of Venetian beauty who knew how to capture the serenity of the city's canals, the sweet pink tones of its massive churches and the

distinctive look of its palaces in delightful detail.

Highly skilled in the use of perspective, he was extraordinarily adept at incorporating sequential depth planes in his paintings and very skillful in his use of atmospheric effects.

Main Ideas

- Baroque painting is distinguished by a profusion of shapes and exaltation of motion.
- The onset of the Baroque period coincides with the *tenebrist* work of Caravaggio, Ribera, and de la Tour.
- Annibale Carracci combines in an eclectic style Mannerism's greatest achievements.
- The leader of Venetian Baroque is Giambattista Tiépolo, a painter of cerulean lights and dizzying movements.
- Canaletto represents Venetian landscape art.

BAROQUE PAINTING IN SPAIN

The patronage of the last kings of the Austrian House and that of the Catholic Church and its powerful religious orders enabled Spain to become a major center of international art.
It also produced an exceptional array of genial painters whose works span the last manifestations of Mannerism, up to the dawn of realism.
Below are the stylistic traits of the most outstanding artists of the period.

Francisco de Zurbarán. Still Life (1633). Oil on canvas, 107 × 60 cm. Norton Simon Foundation, Los Angeles.

Francisco de Zurbarán. St. Hugo Visiting the Refectory *(1633). Oil on canvas, 307 × 262 cm. Museum of Fine Arts, Seville. The quality of Zurbarán's whites are unmistakable.*

He paints portraits of monks whose habits of heavy white fabric acquire a sculpture-like plasticity. "Zurburán's whites" are unique.

Bartolomé Esteban Murillo (1617–1682) is the truest representative of Sevillan Baroque. Murillo was influenced by Ribera, Zurbarán, and the Flemish and Venetian masters. Among his first famous works are several *tenebrist* paintings (today in different collections) painted for the Franciscan convent in Seville: *St. James of Alcalá Feeding the Poor*, *St. Francis*, both at the Academy of San Fernando in Madrid, and *The Kitchen of Angels* at the Louvre.

Murillo painted a number of genre paintings in *tenebrist* style, a series being dedicated to women (*Grandmother Delousing Her Grandchild, Gallegan Women*

The Andalusian School

Francisco de Zurbarán (1598–1664) endows the humble subjects he paints with almost mystical qualities. The artist bestows on his figures a particular illumination and chromaticism that imparts a reverential air to the characters in his monastic paintings. These mystical qualities are seen in his series of murals at the Cartesian Convent of Jerez (displayed today in museums in Cádiz and Grenoble) and at the Hieronymite monastery at Guadalupe (still there today). A genial painter, his realism does not detract from his mysticism.

Bartolomé Esteban Murillo. Children Eating Melon and Grapes, *Oil on canvas, 103.6 × 145.9 cm. Pinacotheca of Munich.*

at the Window, Old Woman Spinning at the National Gallery), and another series dedicated to popular themes featuring children as the main protagonists. These are dynamic, accurate, and highly realistic paintings that show humble but vivacious street children. *Children Eating Melon and Grapes* and *Children Playing Dice* are, perhaps, the best known scenes.

Beginning in 1650, Murillo abandons the *tenebrist* and realist tendency in his painting and adopts a new style of lighter colors and formal idealized figures. Representative of this new style is his *Immaculate Mary*, called *The Monumental One*, done for St. Francis of Seville (today in the Museum of Fine Arts) which is a true iconographic reference work for Marian painting.

Among the most representative of Murillo's idealistic Baroque paintings are *Virgin with Child and Saints* (at the Louvre) and *St. John the Baptist As a Child* and *Christ Child Shepherd* (both at the Prado Museum). These works display an overstated piety by the artist who came to be known derisively as the painter of children and angels.

Murillo portraits are noted for their somber realism, which is well suited to the austerity of figures such as *Don Juan Antonio of Miranda* (Dukes of Alba Collection), or the so-called *Knight with Gorget* (Prado Museum).

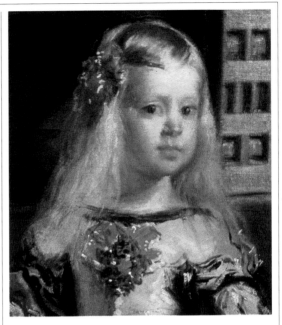

Diego Velázquez. Las Meninas (about 1657), 276 × 318 cm. Detail of the infant's head. Prado Museum, Madrid.

Madrid School. Diego Rodríguez de Silva y Velázquez (1599–1660)

Velázquez is considered by many to be the greatest painter of all time. Others call him the *painter of truth* for his ability to portray the essence of a subject. Velázquez is the first modern painter in terms of technique, anticipating Delacroix and Degas by more than two centuries.

Basically, Velázquez is an unparalleled portrait artist who uses a sober palette and, with the exception of isolated areas on the canvas, applies colors in a "caressing" manner. Proof of this is that Velázquez's canvases hardly display the cracks characteristic of old paintings.

Velázquez's characters, whether kings or buffoons, are always serious and serene and he captures their essence in brushstrokes that even to the expert eye are unusual in their synthetic value and technical execution. The silver-gilded dress and the hands in the portrait of Infant

Margarita of Austria are true miracles of pictorial achievement that we see repeated in the head of Prince Baltasar Carlos and in the fleshiness of Venus in the mirror, the only nude attributed to Velázquez.

The portrait of Pope Innocent X is one of the best in art history. Velázquez's ingeniously modern brushstrokes and tonalities reveal the psychological traits of the Pope who fought against Jansenism.

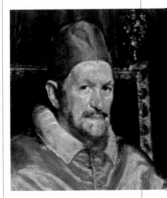

Diego Velázquez. Portrait of Pope Innocent X (1648), detail of the head. Oil on canvas. Galleria Doria, Rome.

Main Ideas

• The Spanish Baroque style first evolved in the schools of Andalusia, Madrid, and Valencia, where Ribera's *tenebrism* originated.
• The greatest representatives of the Andalusian School are Zurbarán and Murillo, primarily painters of religious themes.
• The indisputable master of the Madrid School was Velázquez. Called the painter of truth, Velázquez is the first technically modern painter and one of the most genial portrait painters of all times.

THE FLEMISH-DUTCH BAROQUE PERIOD

Because of Flanders' continued dependence on the Spanish throne until 1714, after Holland had already broken away from Spain, the baroque style of Flemish painters reflects their dependence on the royal family and on the ecclesiastical hierarchy of the Catholic Church. On the other hand, Dutch painting took a more nationalistic and bourgeois course, which led to a different style with different objectives.

• •

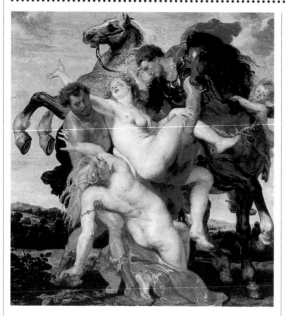

Peter Paul Rubens. The Abduction of Leucipus' Daughters *(1616–1618). Oil on canvas, 209 × 222 cm. Pinacotecha of Munich.*

The Height of the Flemish Baroque Period

Peter Paul Rubens (1577–1640) was a tenacious copier of works by Caravaggio and, especially, by Titian, Veronese, and Tintoretto, who influenced his colorist paintings. Rubens' grandiose style, dominated by robust forms, is unmistakable. His compositions, based on curvilinear sketches, tend to move the spectator's eye along a diagonal path in the painting. *The Fall of the Damned* and *The Lion Hunt* are good examples of this trait in his compositions.

Anton van Dyck. King Charles I Hunting *(1633), detail. Oil on canvas, 212 × 172 cm. Louvre Museum, Paris.*

Surrounded by apprentices and assistants, Rubens' artistic production was enormous (more than 2,500 works), rich in quality, and original in its aesthetic contributions. He added to the iconography of the female nude a new paradigm generously endowed in flesh and rhythms, both in pose and robustness of the anatomical reliefs. The paintings that best represent this female model are *The Abduction of Leucipus' Daughters* and the very famous *The Three Graces*.

Anton van Dyck (1599–1641). A disciple and collaborator of Rubens, van Dyck was influenced by Rubens' colorism and fleshy nudes, as his *Magdalene* at the Bordeaux Museum illustrates. His admiration for Caravaggio is quite evident in his religious works which exhibit clear dramatic exaltation and *tenebrist* displays in his treatment of chiaroscuro.

However, above all else, van Dyck was a great portrait artist, a specialty that he developed based on contemporary aesthetic conventions dictated by portrait painting of English aristocrats. A good example of this style is seen in his famous *Charles I Hunting*. The pictorial qualities shown by the king's image (starting with his attire) are the result of an exquisite balance between technique and sensibility. Official court painter for Charles I, van Dyck established the model that inspired future English portrait artists.

Rembrandt van Rijn (1606–1669) is the leading representative of Dutch Baroque painting. Despite the fact that he never left Holland, he was very knowledgeable about the work of Italian painters who were well represented in his country.

An admirer of Caravaggio, Rembrandt makes use of intense chiaroscuro and a *tenebrismo* in which the light does not always come from a lamp or from the same direction. In paintings such as his famous *Nightwatch* (Rijksmuseum, Amsterdam), Rembrandt's

treatment of light is reminiscent of de la Tour's, while in other paintings (*The Adulteress*, for example) the light seems to emanate from the figures. With respect to composition, Rembrandt follows the Baroque tradition, which emphasized a diagonal composition.

What distinguishes Rembrandt from other Baroque painters is the way he works the pictorial material, applying generous impastos of paint with a brush and, at times, with a palette knife or his fingers. The important role he assigns to the *color textures* makes Rembrandt's paintings among the most important in the history of art. *The Impudent Ox* (Louvre), Rembrandt's most representative work in terms of technical liberties and thematic eclecticism, approaches more the current idea of what constitutes a work of art than what constitutes a Baroque painting.

The Intimate Realism of Johannes Vermeer

Johannes Vermeer (1632–1675) ranks, together with Rembrandt, among the top Dutch Baroque artists, even though his work, consisting of elaborate prints, chiaroscuros, and glazes, does not totally correspond to what we usually think of as Baroque. The *tenebrist* influence disappears in Vermeer and natural light permeates his domestic scenes through windows and doors, creating a luminous atmosphere in which human figures participate in serene and spontaneous scenes of daily life. Among his better

Johannes Vermeer. The Milkmaid (1658). Oil on canvas, 43 × 48 cm. Rijksmuseum, Amsterdam

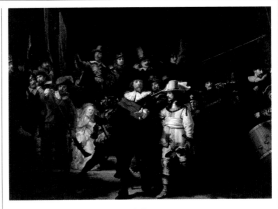

Rembrandt van Rijn. Nightwatch (1649). Oil on canvas, 438 × 359 cm. Rijksmuseum, Amsterdam

known works are *Young Girl Smiling with a Soldier* (1657), *The Cook* (1658), *Woman Reading a Letter* (1665), *Woman Making Lace Cuffs* (1668), *Painter and His Model Posing As Clío* (1679).

Dutch Baroque Landscape Art. Ruisdael and Hobbema

Jacob van Ruisdael (1628–1682) was a poet of nature. A devotee of forest shadows and a superb painter of cloudy skies, he knew how to translate into colors the different hues of light that invaded the forests of his native land at dawn or dusk.

Meindert Hobbema. River View. Thyssen-Bornemisza Collection.

Meindert Hobbema (1638–1709) is the other great landscape artist of the Dutch Baroque School. His landscapes, in beautiful reddish and bluish-green tones, convey a serene and intimate atmosphere as if they were extensions of the interior of a tranquil Dutch home.

Main Ideas

- The most noteworthy styles of Flemish Baroque are those of Rubens and van Dyck.
- Dutch Baroque painting includes the work of Rembrandt, Vermeer, and the two leading representatives of the landscape school: Ruisdael and Hobbema.

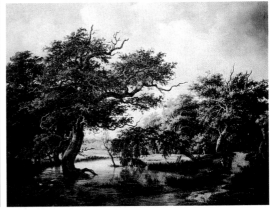

FRENCH BAROQUE STYLES

French painting of the seventeenth century, which produced *tenebrist* artists like Georges de la Tour, was inspired by both foreign Baroque influences and by the teachings of the French Academy of Painting and Sculpture, which subscribed to a more classical approach to art.

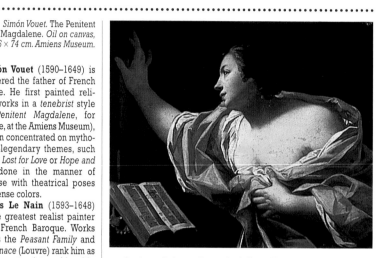

Simón Vouet. The Penitent Magdalene. *Oil on canvas, 106 × 74 cm. Amiens Museum.*

Simón Vouet (1590–1649) is considered the father of French Baroque. He first painted religious works in a *tenebrist* style (*The Penitent Magdalene*, for example, at the Amiens Museum), and then concentrated on mythological-legendary themes, such as *Time Lost for Love* or *Hope and Fame*, done in the manner of Veronese with theatrical poses and intense colors.

Louis Le Nain (1593–1648) was the greatest realist painter of the French Baroque. Works such as the *Peasant Family* and *The Furnace* (Louvre) rank him as the foremost painter of humble and bourgeois life. The figures in his scenes are highly detailed and rendered with clear and sober colors.

Charles Le Brun (1619–1690) was a disciple of Vouet, a court artist, a decorator of Versailles (*The Hall of Mirrors*, for example) and the director of the French Academy of Painting and Sculpture. His works epitomize the academic and decorative style of the Louis XIV period.

Nicolas Poussin (1594–1665), who worked most of his life in Rome, exerted a great influence on the Academy. A staunch believer in the superiority of drawing over color, he was a great admirer of Raphael and Titian. He held, however, Caravaggio's works and the Baroque principles in contempt. Poussin's paintings herald the beginning of Neoclassicism in terms of their themes (*Venus and Adonis, A Poet's Inspiration, The Acadian Shepherds, The Asdob Plague, Triumph of David*) and aesthetic treatment.

Claudio Gellee (1600–1682), called *Lorraine* after the region in which he was born, is the most representative landscape painter of seventeenth-century France. The unusual views and light effects in his works (scenes of dawn, dusk, open spaces with Roman ruins, ports) presage Romantic landscape painting.

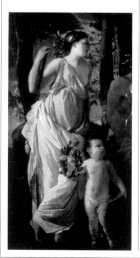

Nicolas Poussin. The Poet's Inspiration *(1630), fragment. Oil on canvas, 214 × 184 cm. Louvre Museum, Paris.*

Late French Baroque. The Rococo Style

At the end of the seventeenth century, French painting renounced classicism. The new lighthearted, poetic, and creative style that emerged created

Main Ideas

• French painting of the seventeenth century wavers between an eclectic Baroque style epitomized by Vouet, the classicism espoused by the French Academy of Painting and Sculpture (Poussin and Le Brun), and the realism of Louis Le Nain.

• The most original expression of French Baroque is Rococo. This style emerged at the beginning of the seventeenth century and prevailed throughout most of the eighteenth century until the fall of the old regime and the emergence of Neoclassicism.

• The most genuine representatives of Rococo painting are Watteau and Fragonard. Their works belong to the *fête galante* and love genre.

highly expressive artistic works. This style, called Rococo, reflects a colorful, theatrical, and pleasure-seeking society represented in a series of brilliant and sensual paintings.

Jean-Antoine Watteau (1684–1721) is the foremost representative of the Rococo style and of the *fête galante* genre. He raised this style to the highest degree of refinement through the use of vivid colors (applied with a light, expressive brush) and through his drawings, which constitute the most fascinating part of his production. Watteau's landscapes are highly melancholic. His famous canvas *Departing for the Island of Cythera*, which earned him entrance into the Academy, is a melancholic elegy to youth and love. His works include several *fête galante* scenes such as *The Elyssean Fields*, *Encounter in the Park*, and *The Indifferent One*.

Françoise Boucher (1703–1770), a painter of solid training, marks the transition between the two leading representatives of the Rococo style: Watteau and Fragonard. His paintings show a predilection for classicism and for the beauty of the female nude in works such as *Rinaldo and Armida* and *Diana in the Bath*. He also produced exquisite red crayon and chalk drawings.

Jean-Honoré Fragonard (1732–1806) is the last of the major Rococo painters. His strong training in the arts enabled him to bestow a superior plastic quality to his theatrical compositions, landscapes, domestic, and *fête galante* scenes. Fragonard's quick, spontaneous brushstroke, like Watteau's, is a precursor to Impressionism.

Jean-Antoine Watteau. Departing for the Island of Cythera (1717), detail. Oil on canvas, 193 × 128 cm. Louvre Museum, Paris.

Significant among his important works are his nudes (*The Bathers*); his series of paintings on the history of love that he executed for Madame Du Barry; his so-called libertine paintings (*The Swing* and *La Rosquilla* for example) as well as his extraordinary, distinctly modern portraits like, for example, *The Abad of Saint-Non*, and *Portrait of a Young Girl*.

French Pastel Painting. Quentin de la Tour

Pastel painting represented a true innovation in eighteenth-century France. No longer a drawing specialty, pastels became with Maurice Quentin de La Tour (1704–1788) an artistic medium comparable to oil painting. This is particularly true in de la Tour's magnificent portraits in which he flatters his subjects by highlighting their luxurious attire, adornments, and surroundings. He also pays careful attention to the formal aspects of his portraits such as color and, especially, the psychological traits of his subjects, as seen in works like *Portrait of the Marquise of Pompadour* (Louvre) and his own *Self-Portrait*.

*Jean-Honoré Fragonard.
La Rosquilla. Oil on canvas,
45 × 37 cm. Private Collection, Paris.
This small work is the most representative of the so-called libertine painting of the Rococo.*

THE PILLARS OF NEOCLASSICISM

Rococo was the last style associated with the old regime ruled by the monarchy and nobility. The French Revolution and an encyclopedic outlook on knowledge opened the way to a new way of thinking based on reason. These principles were also embraced by contemporary art. Furthermore, the discovery of the ruins at Herculaneum in 1719 and Pompeii in 1748 and the German Wickelmann's theories on Greco-Roman art prompted a veritable boom in the popularity of classical art. Artists searched for a return to the formalism of the classical past. The new classicism that emerged was unquestionably dominated from 1775 to 1867 by two artists, David and Ingres.

In works based on classical themes such as *Attendants Carrying the Bodies of Brutus' Children* (1785) and *The Death of Socrates* (1787), David extols heroic sacrifice and stoicism.

The realistic tendency in David's painting is evident in his famous canvas *Death of Marat* (1796), which exhibits an almost mystical naturalism and, especially, in his many superb portraits, including *Mme. Récamier*, *Monsieur Alphonse Leroy*, and *The Lavoisier Couple*.

David. The Death of Marat *(1793), detail. Oil on canvas, 128 × 165 cm. Royal Museums of Fine Arts, Brussels.*

Jacques-Louis David. The Oath of the Horacii *(1784), fragment. Oil on canvas, 425 × 330 cm. Louvre Museum, Paris.*

Jacques-Louis David (1748–1825) Master of Neoclassicism

Although he won the Gran Premio di Roma in 1774 for his work entitled *Eristratus Discovers the Cause of Antioch's Illness*, it is David's *Oath of the Horacii* (1784) that embodies the stylistic traits of Neoclassicism summarized as follows:

• Clarity of exposition. Balance between form and content.
• "Frieze-style" compositions with an open-ended format that exhibit simple, horizontal, non-rhythmical continuity.
• A mostly chiaroscuro design.
• Directional treatment of light, in the manner of Caravaggio.
• Colors that preserve total independence, with each one in its place and not influencing another.

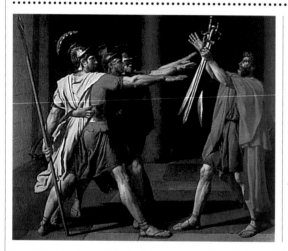

A MARAT.
DAVID

The romantic tendency is apparent in David's *Napoleon Crossing the Alps* in which the artist abandons the rigid horizontal "frieze" format and presents a dynamic composition whose focus is the ascending diagonal fashioned by the horse, the cape, and the right arm of the hero.

David's definitive work, or at least the most famous one, is his giant composition *The Coronation of Napoleon*, an oil on canvas measuring 6.10 × 9.30 meters. It is an impressive painting in which all of David's genius is shown in its full splendor. The composition, meticulously worked (preparation of the canvas alone took one year), shows a hieratic penchant that is justified by the scene's own solemnity. In this exceptional display and masterful design, the colors are subordinated to the realism of the "official chronicle" and, as is the case with all of David's work, the shapes are modeled through chiaroscuro.

Jean-August-Dominique Ingres (1780–1867)

A student of David, Ingres is the most important artist to carry on the legacy of Neoclassicism. Less interested in political, social, or ethical themes, his style is distinguished by an emphasis on drawing over color.

With Ingres, interest in Neoclassical painting shifts towards genuinely aesthetic concepts: form embodies the highest aesthetic value, with content being subordinated to it.

Classical themes painted by Ingres rely on a Davidian iconography, particularly in *The Intervention of the Sabine Women* (1799) and *The Ambassadors of Agamemnon* (1801).

His Napoleonic portraits mark Ingres' role as the emperor's "official painter." *Napoleon, First Consul* (1804) is a realistic portrait in which infinite shades of chiaroscuro define the texture of the clothing within the painting. In this portrait, the artist uses contrasting colors to highlight Napoleon's red velvet robe.

Ingres' *Napoleon Enthroned* (1806) presents a "divine" vision

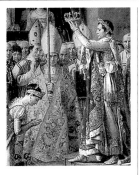

David. Napoleon's Coronation *(1805–1807), detail.*
Oil on canvas, 930 × 610 cm.
Louvre Museum, Paris.

of the emperor reminiscent of a Roman cameo. A hieratic expression underscores the pompous, authoritarian, and distant demeanor of the figure.

The female nudes are a true reflection of Ingres' classicism. His bathers and odalisques are beautiful intellectualized portrayals that project, without anecdotal pretenses, an ever elegant sensuality. In this sense, Ingres is the most classical of all the Neoclassic artists. At times, his works display a Praxitelian influence (*The Fountain*), at other times they are more Baroque and consistently Raphaelian (*Odalisque with Slave*, *Bather of Valpinçon*, *The Turkish Bath*, *The Great Odalisque*).

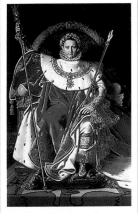

Jean-August-Dominique Ingres.
Napoleon Enthroned *(1806).*
Oil on canvas, 165 × 263.5 cm.
Army Museum, Paris.

Pencil and oil portraits are considered the best and most genuine of Ingres' works. An undisputed master of drawing, he displays an expressive flair characterized by fluid and precise outlines that he enriches with soft shadings. His portraits, such as *Mme. Moitessier*, *Mme. Ingres*, *Nicolo Paganini*, *The Princess of Broglie*, and *Monsieur Bertin*, reveal Ingres' penetrating understanding of the models' minds.

Ingres. Large Bather *(1808).*
Oil on canvas, 97.5 × 146 cm.
Louvre Museum, Paris.

Main Ideas

- Neoclassical painting reflects an encyclopedic outlook on reasoning and a revaluation of classical antiquity.
- Drawing is the most important element of Neoclassical painting in which color is subordinated to form.
- Neoclassical compositions suggest a classical frieze, their structures being simpler and horizontally-ordered rather than intricate and rhythmical.
- The two most important artists of Neoclassical painting are Jacques-Louis David and Jean-August-Dominique Ingres.

THE ROMANTIC TENDENCY PRIOR TO ROMANTICISM

Romantic themes portray an event or plot and, in the process, strive at stirring the spectators' emotions and influencing their actions. Romantic works are, then, artistic products that have a dialectic origin and whose purpose does not necessarily depend on the historical time period in which they occurred. What, however, pertains to a given time period is the event itself, real or imaginary, and the stylistic and technical manner in which it is portrayed. With respect to the motives that characterize Romantic artworks, it is evident that the art of painting has served to promote special interests or convey special feelings through the ages, albeit more so in some than in others. It has served, for example, to motivate patriots, inflame soldiers, move believers, evoke pity, etc. It is very difficult to believe that a painter like, for example, the Dutch Vermeer could have had Romantic leanings almost two centuries before Romanticism. On the other hand, the same supposition may plausibly hold if we refer to artists like Rembrandt or the Flemish Rubens, both contemporaries of Vermeer. We shall elaborate further on these ideas in the next sections.

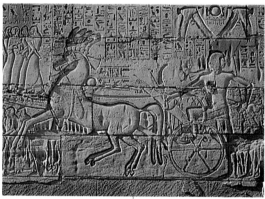

Ramses II in His War Chariot *(1301–1235 BC). Bas-relief from the great Temple of Amon, Thebes.*

In Ancient Egypt

The reliefs that decorated the large walls of the temples in ancient Egypt were plastic renditions of mythological legends or war scenes in which the pharaoh always appeared as conqueror of neighboring peoples. Despite the fact that Egyptian aesthetic precepts left no room for naturalism and expressionism, we could presume that the heroic character of those representations had a romantic intention: to influence the behavior of contemporary viewers, to arouse in them feelings of admiration for the pharaoh as a natural conqueror.

In Imperial Rome

In the third century we find numerous examples of art that have a romantic or narrative purpose.

The Ludovisi Sarcophagus, for example, contains the representation of a battle between the Romans and the Dacians, a fragment of which we reproduce and which contains the figures of four

The Ludovisi Sarcophagus *(circa 260), detail. National Roman Museum, Rome.*

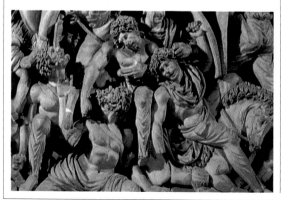

Main Ideas

- The motivations that inspire a romantic work have a dialectical origin and are not exclusive to any one historical period.
- Poignant romantic images belong to the naturalist schools and have generally emerged in periods of Baroque taste.

vanquished warriors. It is clear that independent of the heroic-patriotic sentiment inspired by the scene, the romantic interest in expressing human suffering is wholly comparable to the emotional and even plastic content of Géricault's *The Raft of the Medusa*, a work that marks the onset of French Romanticism of the twentieth century.

During the Baroque

The deposition (descent from the cross), one of the main themes of Christian iconography and whose purpose was to evoke the pity and contrition of the faithful, acquired an important role during this period.

Depositions of clear romantic intent appeared in Mannerist and Baroque painting many years before the actual Romantic period. For example, in Rubens' highly dynamic composition of the descent, the painting focuses on the pathetic figure of the beautiful and tortured body of Christ that collapses into the arms of the disciple who is catching it. By combining the concepts of life, agony, and death, the painting is strongly romantic. It may affect viewers differently depending on their own particular faith and piety. However, this does not interfere with the overall emotional impact that the work produces on its own.

Peter Paul Rubens. The Descent from the Cross *(1612), detail of Christ's body. Oil on board, 310 × 420 cm. Amberes Cathedral.*

The Executions of May 3, 1808, in Madrid

This painting is one of the most vehemently romantic paintings in all of the history of art. It was painted by Francisco de Goya in 1814, four years before *The Raft of the Medusa* and sixteen years before Delacroix painted *Liberty Leading the People*.

The Executions is the first great modern work that denounces the absolute insanity of war. In this magistrally thought-out scene, emotive and cerebral at the same time, Goya does not fall into the facile demagoguery of "the good guys against the bad guys." He portrays some men who are about to die facing other men without faces (a war machine) who are about to kill. They represent two groups that have been institutionalized by human stupidity, neither good nor bad, neither brave nor cowardly. The tables might be turned another day. The condemned men are, in any case, poor and desperate.

The treatment of the light and color make this a totally magisterial work of surprising modernism. The white shirt of the character on which the light is focused is rendered with a simply genial display of furiously applied impastos, as if the artist were living the picture rather than painting it.

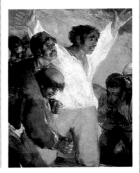

Francisco Goya. The Executions of May 3, 1808. Detail.

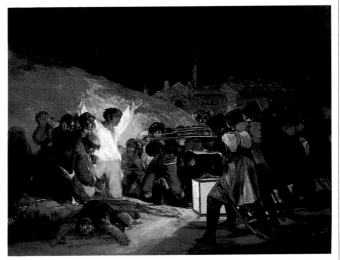

Francisco Goya (1746–1828). The Executions of May 3, 1808, in Madrid *(1814). Oil on canvas, 345 × 266 cm. Prado Museum, Madrid.*

PAINTING IN THE ROMANTIC PERIOD: ROMANTICISM

Romanticism in the nineteenth century was an aesthetic movement whose paintings, which were closely linked to the literature of the period, were created as a reaction to traditional academic principles. Romantic works created a world full of passions and emotions and dealt with themes such as death, religion, patriotism, exaltation of genius, heroes, and fantastic deeds. Oriental and medieval settings were among the most popular themes.

Henry Fuseli, Achilles Trying to Capture Patroclus's Shadow *(1803). Oil on canvas, 71 × 91 cm. Art Museum, Zurich.*

William Blake. Satan Contemplating the Loves of Adam and Eve *(1808). Watercolor and pencil, 38 × 50.5 cm. Illustration for Milton's* Paradise Lost. *Boston Museum of Fine Arts.*

English Romanticism

The seeds for English Romanticism were sowed by two great artists of the second half of the eighteenth century and first quarter of the nineteenth century, Henry Fuseli (1741–1825) and William Blake (1757–1827). These artists created a world of visionary images some of which, because of their markedly symbolic character, are associated with the symbolist current in art.

Fuseli, whose real name was Heinrich Füssli, was born in Zurich but was educated and lived as an artist in England. A student of classical antiquity, he displayed a predilection for biblical themes and for the works of Shakespeare, Dante, and Homer. His paintings *Achilles Trying to Capture Patroclus's Shadow* and *Satan and Death Separated by Fate* show clearly Michelangelo's influence in the strong muscular structures of the figures rendered in dynamic chiaroscuros. His literary characters display exaggerated, rhetorical gestures, as in the case of *Lady Macbeth* who seems to have risen from the shadows of insanity, or of *Kate*, William Cowper's hallucinated character.

William Blake, engraver, painter, and poet who loved to experiment by combining pictorial art techniques, was an artist with a romantic soul. In Blake's works it's impossible to separate poetry from plastic art.

In his best illustrations, he combined engraving techniques with watercolor and pencil drawing, developing a style that reflects the following aesthetic conviction: "*A work of art depends on form and line. Adding color is a mistake.*"

These are the words of an artist who was greatly influenced by Michelangelo as seen in his paintings of nudes. He also created a world of symbolic figures that we will discuss when we treat Symbolism as an historical period.

Landscapes in English Romanticism

Some of the more outstanding works of English Romanticism belong to landscape painting and its two leading representatives, John Constable and William Turner.

These two great artists express their romantic sensibilities through

the scenery of their native land. Constable and Turner broadened the repertory of Romantic themes by introducing a new approach to landscape painting that avoids modifying reality. Both artists painted with a Romantic realism that conveyed not only the true nature of the landscape but also the emotions that the reality evoked.

Constable and, especially, Turner also developed an intimate landscape that was not readily understood by the majority of the public of the time. They carried out studies in which the landscape was no longer just a model to be copied, but also the conveyor of sensations to be expressed. This trait makes both Constable and Turner pre-Impressionist painters.

John Martin (1789–1854). While Constable and Turner are the originators of modern landscape painting that is inspired by nature, John Martin represents an

John Constable. The Mill at Flatford *(1817), detail. Oil on canvas, 127 × 102.7 cm. Tate Gallery, London.*

opposite trend. He was an artist who painted in the classical manner and wished to reach "sublime" aesthetic levels by translating his Romanticism into "apocalyptical" landscapes in which diminutive men and women move through grandiose, enchanted outdoors.

Samuel Palmer (1805–1881) provides another good example of the originality of English Romantic landscape painting. His most interesting works are the landscapes of the so-called Shoreham Period (1823–1835). In his work, *The Gardens at Shoreham,* in which he subdivides and defines shapes with a pictorial boldness that in those days had no precedent, Palmer displays a masterful use of watercolors and oils.

The Pre-Raphaelites

In 1848, a group of seven London artists founded a Pre-Raphaelite Society. Isolated from the revolutionary movements that were troubling Europe then (1848 is the year of the *Communist Manifesto* by Marx and Engels), they tried to introduce a new Christian art inspired by Raphael's works. Although today we would call their style decadent, it revealed a solid craft and strong moral conviction.

William Holman Hunt (1827–1910), Dante Gabriel Rossetti (1821–1882), and John Everett Millais (1829–1896) were the most noteworthy Pre-Raphaelites.

Samuel Palmer. In a Garden at Shoreham *(1829). Oil on canvas, 2 × 28 cm. Tate Gallery, London.*

John Martin. The Great Day of Wrath *(1851). Oil on canvas, 303 × 197 cm. Tate Gallery, London.*

Main Ideas

• Romanticism institutionalized the cult of personality and emotions.
• The favorite themes of Romantic painters are death, heroes, patriotism, and Oriental and medieval exoticism.
• The pillars of English Romanticism were Henry Fuseli and William Blake, artists who were strongly influenced by Michelangelo and whose art was highly symbolic.
• English Romanticism also finds expression in the landscape paintings of Constable, Turner, Palmer, and Martin.

FRENCH ROMANTICISM

Neoclassicism, which already started showing signs of change with David,
is the point of departure for French Romantic painting.
While in other countries Romanticism arises in opposition to classical
French cultural influences, in France, however, Romanticism does not
develop outside of Neoclassicism, but arises from it.

Anne-Louis Girodet (1767–1824), one of David's favorite students, distanced himself so much from his teacher that David once said: *"Either Girodet is crazy when it comes to painting or I don't understand absolutely anything. What a pity that despite his talents, he'll only turn out nonsense."*

The literary inspiration and the pronounced bourgeois taste of Girodet are apparent in his painting *Entombment of Atala*, which shows a religious and exotic proclivity along with a simulated sensuality. *Ossian Welcoming the Napoleonic Officers*, dated 1802, (an apotheosis in which French servicemen who died for their country are welcomed by the mythical Ossian into a mysterious post mortem world) is his most allegorical work.

Girodet's works were criticized for being too daring and too heterodox in their treatment of light, and for lacking classical balance and serenity.

Antoine-Jean Gros (1771–1835) is another precursor of Romanticism who, like Girodet, was another of David's favorite students.

While Gros never renounced David's teachings, his paintings,

Anne-Louis Girodet, Entombment of Atala *(1808).*
Oil on canvas, 267 × 210 cm. Louvre Museum, Paris.
In this emotive and sentimental work, Girodet,
a painter of Romantic taste, draws on a literary theme.

which hint at influences of Rubens and Veronese in their agile and textured brushstrokes, are technically and conceptually far removed from David's style.

Gros heralds the imminent rejection of the academic style and places himself instead within the romantic current of French painting.

Théodore Géricault (1791–1824) is an artist of rich and brilliant chromaticism who planned rigorously his paintings. His clear inclination to morbid realism is shown in his *Cart Carrying Wounded Soldiers*. Painted in 1818, this work signals an end to the era of Napoleonic glorification in French art and gives way to themes related to its decline.

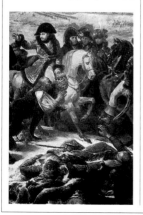

Antoine-Jean Gros.
The Battle of Eylan *(1808), detail.*
Oil on canvas, 800 × 533 cm.
Louvre Museum, Paris.
This singular conception and the agile and textured brushwork of this composition underline Gros' Romantic aesthetics.

Above all, Géricault is the author of the enormous painting *The Raft of the Medusa* (4.91 × 7.16 m). In this painting, which is a plastic narrative of the tragedy befalling the survivors of the shipwrecked frigate *Medusa* in 1816, Géricault tries to express an allegory on the fatalism of human destiny.

In the dramatic gestures and the anatomy of the bodies we recognize the influences of Michelangelo and Rubens, while the unidirectional light and the crisscrossed diagonals giving structure to the composition remind us of the Baroque dynamism of Caravaggio.

Eugène Delacroix (1798–1863) is the Romantic painter par excellence and the link between the first Romantic artists and the painters of the end of the nineteenth century.

Like his great predecessors of pictorial Romanticism, his style is marked by the Renaissance and Baroque influences of Michelangelo, Rubens, and Veronese.

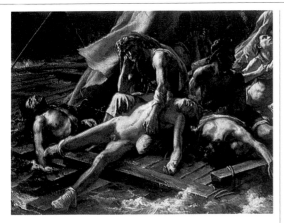

Théodore Géricault. The Raft of the Medusa *(1819), fragment. Oil on canvas, 716 × 491 cm. Louvre Museum, Paris. Géricault's great painting is the synthesis of Renaissance and Baroque aesthetics in the service of Romantic rhetoric.*

His first great work, *Dante's Ship*, whose tragic colors evoke the darkness of hell's lake as described by Dante in his *Divine Comedy*, reveals the basic traits of Delacroix's painting style:
• His admiration for the anatomies of Michelangelo and Rubens.
• A constant emphasis on human suffering.

Eugène Delacroix. Dante's Ship *(1822). Oil on canvas, 246 × 189 cm. Louvre Museum, Paris. The compositional structure in this painting is a main characteristic found in many of Delacroix's work.*

• A consistent approach to composition whereby the viewer's eye is lead across the entire canvas by means of rhythmical, convoluted lines pulled taut by figures or illuminated spaces.

Main Ideas

• French Romanticism evolves from the Neoclassical School, with which it co-exists until the advent of Impressionism.
• Historians place the cross-over from Neoclassical tendencies to Romantic painting between *The Raft of the Medusa* and 1830.
• French Romantic painting reaches its full expression and development in the works of four great painters: Girodet, Gros, Géricault, and Delacroix.

His evolution toward a stronger chromaticism can be appreciated in the large compositions that he himself called "mes trois massacres" (my three massacres): *The Massacre at Chios*, *The Death of Sardanapalus*, and *The Conquest of Constantinople by the Crusaders*.

The Death of Sardanapalus is most characteristic of Delacroix's style and relates the killing of the harem women whose nude bodies recall much of Rubens' aesthetics. A bloody apotheosis is developed over a cascade of clothing whose red crimson color emphasizes the bloody character of the theme.

In a more sincere chromatic vein, Delacroix painted one of his most famous works, *Liberty Leading the People*, a barricade scene of the July 1830 Revolution. The theme is one of the few instances when the artist abandons literary topics and treats an historical event through a politically-motivated allegory.

Eugène Delacroix. The Massacre at Chios *(1823–1825). Oil on canvas, 417 × 354 cm. Louvre Museum, Paris. Delacroix once again uses a composition of wrapping curves to guide the viewer's eye over the canvas.*

IMPRESSIONISM IN NINETEENTH-CENTURY PAINTING

When a new style or tendency emerges (and is either quickly rejected or becomes highly acclaimed), it is wise to ask whether the vogue really represents a true innovative trend or whether it is really a blossoming of ideas that actually coexisted alongside other trends in past periods. Such was the case with Romanticism and the art movement that followed it, European pictorial Realism. Both periods produced artists who, at particular times in their lives, developed strong interests in color and light and experimented with different ways of interpreting them. These artists sought to convey *impressions of color and light* that would suggest shapes without the need for precise outlines. This concept brought artists of the two periods, though separated by a span of years, close to the aesthetic ideas of the historical Impressionist movement.

John Constable. The Reapers of Brighton (1824).
Oil on canvas, 30 × 16 cm. Tate Gallery, London.

Pre-Impressionist Manifestations of English Romanticism

John Constable is a painter whose Romantic spirit found expression in the landscapes of his native surroundings (the Suffolk Valley) and who rejected idealized landscapes in favor of natural ones. If only for this, John Constable can be considered a forerunner of Impressionism. He was also one of the first landscape artists who studied in his paintings the atmospheric effects that different conditions of air, light, or rain had on the natural environment. This novel outlook is mainly apparent in the sketches he did in the open air (true precursors of Impressionism), which he produced with an agile, firm, and quick brush. His 1822 studies of the sky and the sea, his 1824 small notebook sketch of *The Reapers of Brighton*, and his 1831 sketch of *The Cathedral of Salisbury: View from the Meadow* represent extraordinarily bold pictorial renditions. However, Constable never considered these works worthy of being exhibited in public.

William Turner was a painter whose artistic activities were characterized by two opposing drives. On the one hand, he was driven by an interest in success and in recognition by the public and the Royal Academy, to which he was elected a member in 1802. On the other hand, he yearned to free himself from accepted art norms and focus on painting primarily light and color effects. Under the influence of the latter impulse, Turner produced a significant number of works that were later found in his studio and that the painter never made public. They are true abstractions of color that prefigure not only Impressionist paintings, but also non-figurative art.

Good examples of this tendency are his watercolor *The Norham Castle* (1835–1840), and his oil painting, *Rain, Steam, and Speed* (1844).

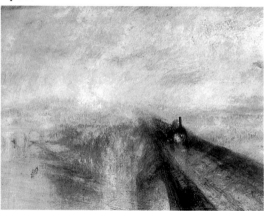

William Turner.
Rain, Steam, and Speed *(1844).*
Oil on canvas, 122 × 91 cm.
National Gallery, London.

Other Evidence of Impressionism in Nineteenth-Century Europe

The Romantic and Realist movements in Europe represent the final steps in painting leading to the definitive exaltation of color and light.

Besides Turner and Constable, the notion that painting meant interpreting light and color to define forms was progressively taking hold among other artists who produced sporadic and "unofficial" works in which they experimented with ideas that were more akin to chromatic contrast than to chiaroscuro. For the most part, these works were preliminary sketches for more definitive works, or freely drawn canvases depicting nature scenes which, we might say, did not compromise in any way the artist's academic reputation.

Géricault himself (1791–1824), not known for his avant-garde ideas, was one of these artists. The painter of *The Raft of the Medusa* produced minor works and studies in which his agile brush and superimposition of unblended colors show a taste for painting not strictly tied to chiaroscuro.

If we stop and think about the Realism of the late Romantics, we find that even Courbet (1819–1877), perhaps the best painter of the period, delights us with very modern brushwork and dark areas in which colors (not just their tonal value) play an

Gustave Courbet.
Stormy Sea *(1869), detail.*
Oil on canvas, 117 × 160 cm.
Louvre Museum, Paris.

important role when painting "minor" themes such as his series of maritime scenes on a stormy sea.

Camille Corot, a Step Away from Impressionism

Camille Corot (1796–1875) was for France what Constable was for England—one of the first landscape artists to paint in the open air. His empirical understanding of light led him to gradually abandon drawing in favor of chromatic impressions. An independent artist capable of assimilating many tendencies, Corot represents the link between the historical and classical landscapes of the past and Impressionist landscapes.

Corot, who once said *"we should never lose the first impression that has moved us,"* painted with short, sensitive brushstrokes. His technique slowly evolved to yield landscapes of imprecise outlines that evoke impressions of light and color that cannot be duplicated. Representative of this style, which brings Corot close to Impressionism are works such as *Dance of the Nymphs* from 1851 and *Memory of Mortefontaine* from 1864.

Camille Corot. The Forest
of Coubron *(1872).*
Oil on canvas, National
Gallery of Art, Washington.
In this late landscape work,
Corot's painting is
conceptually Impressionistic.

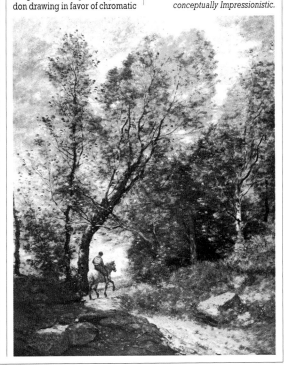

Main Ideas

• Historical Impressionism, like so many other manifestations in the history of art, is the culmination of ideas that had surfaced sporadically in previous periods.
• The most preeminent precursors of Impressionism include the two English painters of Romantic landscapes, John Constable and William Turner, and the Frenchmen Gustave Courbet and Camille Corot.

PAINTING IN THE NINETEENTH CENTURY

THE IMPRESSIONIST MOVEMENT

The great Impressionist revolution and the name "Impressionism" itself derive from Claude Monet's painting entitled *Impression: Sunrise* (1872), whose characteristics justly sum up a new insight into painting. However, it was beginning in 1874, thanks to an exhibition of the so-called "Limited Company of Painters, Sculptors and Engravers," that the young Impressionists began to make collective strides into a painting technique *whose underlying idea was to capture a live moment in the open air* (a plein air) *that cannot be duplicated in terms of time and light*. Impressionism, which initially was a homogeneous style before evolving into several more individualistic styles, can be divided into two periods: the Pre-Impressionist period and the period that evolved from this style, when color was no longer viewed as a complement to form but became something that justified the name of "painting" itself.

Édouard Manet. Argenteuil *(1874). Oil on canvas, 113 × 145 cm. Museum of Fine Arts, Tournay.*

colors that vibrate in the landscapes and in the attire of the figures painted.

A Poet of Light. Claude Monet (1840–1926). Monet is, perhaps, the quintessential Impressionist painter of the period. He paints light that vibrates on objects, in the air, and on the water. His series of paintings focusing on these themes, but viewed in different light conditions, represent the culmination of the Impressionist idea: the *Saint-Lazare Train Station* series in which the central role belongs to the steam belched by locomotives, or the *Rouen Cathedral* series in which he abstains from painting forms and concentrates on creating effects of light.

Camille Pissarro (1830–1903) is a painter who combines a remarkable and highly individual chromatic harmony with a great solidity in the structure of his themes. Cézanne said about him

The Father of French Impressionism. Édouard Manet (1832–1883)

Despite being considered the father of Impressionism, Manet never identified himself completely with the movement. In his 1874 painting *Luncheon on the Grass* (rejected by the official salons), Manet abandons realism and embarks on a painting of luminous quality that displays hardly any of the shade contrasts seen in his *Olympia* and *The Balcony*. Between 1874 and 1875, he paints several Impressionistic works in the open air (*Argenteuil, The Great Canal, The Quarrymen of Berne Street*) with short brushstrokes and rich and luminous

Claude Monet. Cathedral at Rouen: Dawn (1894). Oil on canvas, 73 × 106 cm. Musée d'Orsay, Paris.

Impressionism in Nineteenth-Century Painting
The Impressionist Movement
Impressionist Painting. Other Manifestations

63

that he was the painter who was closest to nature. His works display precise and rounded brushwork, as paintings such as *Corner of a Town: Red Roofs* or *Snow in Lower Norwood* will attest. Pissarro was temporarily drawn to the pointillism of Seurat and Signat, to which he added his own personal touch.

Pierre-Auguste Renoir (1841–1919). Together with Monet, he is considered the other father of Impressionism. Like other

Camille Pissarro. Snow in Lower Norwood. *Oil on canvas, 51.1 × 40.5 cm. National Gallery, London.*

Pierre-Auguste Renoir. Le Moulin de la Galette *(1876), detail. 175 × 131 cm. Museé d'Orsay, Paris.*

Renoir. The Bathers *(1884–1887). Oil on canvas, 170 × 115 cm. Philadelphia Museum of Art.*

Main Ideas

• The basic concept underlying Impressionism is that light makes contours disappear. Form results not from tonal gradation, but from the juxtaposition of colors.

• Shadows are also color. Contrasts between complementary colors acquire a great importance.

• Color, in Impressionism, is profuse but not sharp.

• Impressionist painters do not use black.

• Impressionists make little use of perspective, and when they do, they are guided more by intuition than theory.

• Impressionists want to express the fleeting nature of visual impressions resulting from the changing light.

Impressionists, Renoir sought to avoid tonal modeling as can be seen in works such as *Sailboats in Argenteuil* (1870), *The Grape Pickers*, and *Le Moulin de la Galette* (1876), the latter a master work whose real focus is the human element and the environment. However, Renoir was not particularly fond of painting in the open air. His antipathy to everything that might be considered a prescribed method or doctrine explains why he changed his style and technique so often. Domestic scenes with figures (*La Loge*, for example) show the extent of his rejection of the Impressionist style with the reappearance of black on his palette. Renoir developed other techniques and a new interest in form, particularly in his paintings of women. Here Renoir reveals himself as the most sensual painter of the Impressionist period, articulating through his style the hedonism of Watteau and Fragonard. It has been rightly said that Renoir's paintings, with their daring luminous qualities, reflect the true *joie de vivre*.

Alfred Sisley (1839–1899) is another of great Impressionist landscape painter. A true master, he produced in pure Impressionist style solid drawings and colors that depicted light without the need to rely on contrived techniques. Sisley is a great painter of water and snow, themes in which he imbues an exquisite luminosity whose key lies in the way he works the color of the sky in with the color of the land as if they were one element.

IMPRESSIONIST PAINTING. OTHER MANIFESTATIONS

Despite the fact that the group of painters belonging to "The Limited Society" were at first undeniably united, after eight collective exhibitions members started to move away from the Impressionist precepts. Some turned to more personal styles or individual techniques, such as in the case of the scientific Impressionism of Seurat and Signac, the so-called Divisionism or Pointillism.

Georges Seurat. Seated Model *(1887). Oil on canvas, 15.5 × 24.5 cm. Museé d'Orsay, Paris.*

Paul Signac. The Port of Saint-Tropez *(1894). Oil on canvas. Musée de l'Annonciade, Saint-Tropez.*

Georges Seurat (1859–1891) His Divisionism was an ultimate form of Impressionist expression that applied the theory of color to art. Small points of color, carefully placed in close proximity, are converted into an *optical blend* of juxtaposed colors when caught by the viewer's retina.

However, Seurat's painting is not just scientific. His motionless figures, which alternate in similar poses, are immersed in an almost mysterious, lyrical light. This is especially true for his *Models*, nude figures illuminated with artificial light, whose poses are reminiscent of Ingres and the classics as if they were works from the past that have been given a new Pointillist interpretation. In his large compositions (*Bath at Asnières, Sunday Afternoon on the Island of Grande Jatte* or *The Parade*, to mention the most significant), shapes and lines have been scrupulously organized based on a diagonal or on parallel bands, as in the case of ancient friezes.

Paul Signac (1863–1935) was the greatest theorist of Divisionism in painting. A student of the physics of light and optical laws, he expounded the theory of Pointillism in his book *From Delacroix to Neo-Impressionism*. He states in the book that Divisionism favors luminosity, color, and harmony because of the optical blend of pure colors on the retina, its distinction between local color and the color of light, and the effect of the laws of contrasts.

The Port of Saint-Tropez, for example, is a Pointillist seascape painted exclusively with brushstrokes of pure color (those of the spectrum of white) that are evenly applied.

Georges Seurat. Sunday Afternoon on the Island of Grande Jatte *(1884–1886). Oil on canvas, 306 × 206 cm. Art Institute of Chicago.*

Edgar Degas (1834–1917), a Unique Impressionist

Pressed by his father to become a lawyer, he eventually followed his own inclination to pursue a career in painting. Although he participated in

Impressionist activities, he defended the notion that it was better to paint from memory than in the open air.

Degas painted in an unmistakable style, landscapes, portraits, horse-drawn carriages, extraordinary nudes, and ballet scenes. With sure and free, unidirectional or radial brushstrokes, he materializes in the light the delicate sheers of his ballerinas' tutus and the blurred outlines of their bodies. It is said that *Degas achieved with spotlights the same Impressionist ideal that Monet had achieved in full sunlight.*

Impressionist Influences in Spain

We will focus our attention on the style of three great Spanish painters who, while very different in style, illustrate the expansion of Impressionist ideas outside of France.

Aureliano De Beruete (1825–1912), born and died in Madrid, heralds Impressionism in Spain. His work *Banks of the Manzanares*, which won a gold medal at the National Exhibition of Fine Arts in 1878, embodies the essence of Impressionism and is, undoubtedly, one of the first Spanish landscapes in which color is not subordinated to drawing.

Darío de Regoyos (1857–1913), Asturian by birth and cosmopolitan by vocation, he traveled through France and Belgium and fashioned from his contacts

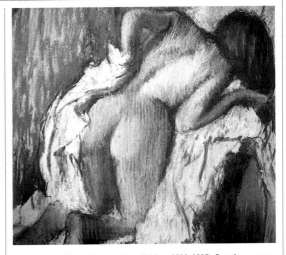

Edgar Degas. Woman Drying Herself *(circa 1890–1895). Pastel on paper, 62.7 × 64 cm. National Gallery of Scotland, Edinburgh.*

Main Ideas

• Impressionism evolved into several distinct and individualistic styles.
• The common characteristic of all painters that today we call Impressionist is their cult for light and color.
• Pointillism is the ultimate expression of Impressionist ideas, developed on the basis of purely scientific considerations.
• European painting at the beginning of the twentieth century was shaped by the Impressionist concept of light and color.

with European artists his own pictorial style: a robust Impressionism influenced, above all, by Pissarro. He is the first Spanish Impressionist and one of the best landscape artists of his time, who is noted for the poised juxtaposition of colors and mastery of shadow tones. His notions on color made him embrace with enthusiasm the Pointillist technique, which he practiced with rare sensibility.

Joaquín Sorolla (1863–1923). Born in Valencia, he is one of the great painters who, at the end of the nineteenth century, achieved a personal style that definitively set him apart from official academic painting.

Sorolla is a luminous painter of very pure, transparent colors, of immaculate whites, blues, greens, and yellows that he imbues in the flesh and dresses of his figures as tremulous reflections of the Mediterranean light. His resplendent palette and poised technique, while not similar to the early Impressionists, make Sorolla more of an Impressionist than the Impressionists themselves. His scenes of children on the Valencian beaches portray a pleasurable impression in sunlight that describes a moment in life that can be captured but not duplicated.

Darío de Regoyos. Vineyard View. *Oil on canvas, 54 × 65.5 cm. Casón del Buen Retiro, Madrid.*

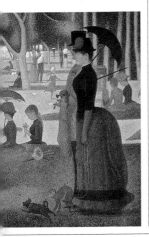

THE STYLE OF POST-IMPRESSIONIST PAINTERS

The ambiguous term *Post-Impressionism* is applied to the works of the greatest French painters of the last decades of the nineteenth century (beginning, more or less, in 1883), such as Cézanne, Gauguin, van Gogh, and Toulouse-Lautrec. They were distinct painters who, stylistically, had very little in common. However, each one distanced himself, in his own way, from Impressionism *in search of a new constructivism that would enable him to capture the lasting truths of nature despite its ephemeral quality.*

• •

Paul Cézanne (1838–1906), creator of a new aesthetic ideal, was one of the artists who most influenced painters of the twentieth century. Based on his own statement, he believed that *art is harmony that parallels nature.* As a result of this vision (parallel elements do not touch), he is the artist who contributed most to the notion that painting should not strictly replicate images from nature.

In Cézanne's paintings, every shape is carefully arranged, defined and, when need be, distorted with slight changes in point of view shifts always favoring the painting's composition and harmony.

Cézanne uses a pale palette, common among Impressionist painters, with some very characteristic "whites" in which all colors of reflected light converge. Cézanne's colors are clean and balanced, wisely contrasted, without sharp tones, although some landscapes and figures herald Fauvism.

Vincent van Gogh (1853–1890). His work is linked to Symbolism, Expressionism, and

Paul Cézanne. Still Life with Curtain *(1899). Oil on canvas, 72 × 53 cm. Hermitage Museum, St. Petersburg.*

Fauvism, but, above all, *van Gogh's paintings are the expression of an exalted passion for painting and a reflection of the artist's own dramatic life.*

Unlike what appearances might suggest, van Gogh was a painter who reflected deeply on his own artistic ideas. However, the emotional ardor, the paranoiac impulse that inspires his colors, contain an obsessive symbolism: loneliness, death, terrible human passions. Referring to his work *Night Café*, he writes: "I have tried to express terrible human

passions with green and red . . ." and, later, ". . . there is an antithesis of greens and reds . . .," and then, ". . . the café is a place where a man can ruin himself, go crazy, or commit murder."

Van Gogh's paintings are unmistakable, passionate in their use of impastos, in the nervousness of his fragmented and sinuous brush, disclosing a profound inner emptiness. In van Gogh's paintings, color, which is a prelude to Fauvism, takes on a symbolism that parallels his state of mind. Though he confessed he wanted to suggest rest and tranquillity in his work *Vincent's Room in Arles*, the work suggests, simply, claustrophobia. The colors and the false sense of balance of several of the objects seem to suggest the mental instability plaguing the artist.

Vincent van Gogh. Night Café *(1888). Lead, watercolor, and gouache, 63.5 × 44.4 cm. Private Collection. Switzerland.*

Impressionist Painting. Other Manifestations
The Style of Post-Impressionist Painters
Symbolism of the Nineteenth Century

67

Paul Gauguin (1848–1903), like Cézanne and van Gogh, inspired the Nabis and was a precursor of the Fauvists and Expressionists.

Gauguin went through an Impressionist phase but, beginning in 1888 with his painting *Vision after the Sermon*, he changed to a symbolist style characterized by the use of flat colors in areas defined by contour lines. Reminiscent of enamel and stained-glass art, the style was known as *cloissonnism*, though Gauguin preferred to call it *synthethism*.

Gauguin affirmed the expressive power of color "by itself" and used it, independent of its imitative implications, to express ideas and symbols. In their disregard for classical perspective and expression of depth through juxtaposition or superimposition, Gauguin's paintings conform to the idea of the future Nabis: *a painting is, essentially, a flat surface covered with colors that are arranged in a certain order*. Gauguin puts this notion in practice during his highly productive Tahitian period, using evocative and brilliant colors and extraordinary juxtapositions of violets, orange, and greens.

Henri de Toulouse-Lautrec, (1864–1901), an aristocrat whose life was embittered because of his deformed legs, shares with van Gogh and Gauguin a tragic existence marked by marginalization and self-destruction,

Henri de Toulouse-Lautrec. In the Salon on Moulins Street (1894). Pastel on paper, 132 × 111 cm. Toulouse-Lautrec Museum, Albi.

though in a completely different environment.

His work represents a true psychological analysis of night life in the Montmartre of his time, of the humanity that populated the contemporary theaters, cafes, and dance halls.

With a style supported by expressive and lavish outlines, Toulouse-Lautrec captured the personality of his people with his elegant sketching and the simplicity of his silhouettes, and with the addition of brilliant color applied with broad and quick brushstrokes of glazes and transparencies.

Through his graphic works, he raised poster illustration to the level of artwork. His lithograph *Moulin Rouge, la Goulue*, of 1891, is the first great work of modern poster art.

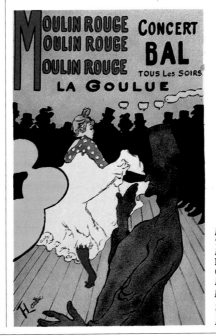

Henri de Toulouse-Lautrec. Moulin Rouge, la Goulue, (1891). Lithographic poster, 117 × 191 cm. Toulouse-Lautrec Museum, Albi.

SYMBOLISM OF THE NINETEENTH CENTURY

Concurrent with the development of Post-Impressionism, a new art movement emerged in Europe. This movement was deeply rooted in literature and exalted the symbolic value of the plastic arts. Its plastic language portrayed known forms that were intended to symbolize other ideas to viewers. In the words of the Symbolist artist Redon:

It's a question of putting the logic of the visible at the service of the invisible.

One cannot speak of a uniform style in the Symbolism of the nineteenth century, but only of some shared characteristics:

• Symbolism displays distinctly subtle colors that often tend to decorativism.

• Symbolism always conveys a literary message that attributes symbolic value to known forms.

Masters of French Symbolism

Gustave Moreau (1826–1898), a great idealist, had a decided influence on literati and artists. His themes and characters are drawn from literature, from the Bible, and from classical mythology: Orpheus, Oedipus, The Sphinx, Salomé.

Independent of their symbolic meaning, Moreau's paintings are rich in plastic values: sumptuous surfaces with incredible glazing effects, reddish and yellowish morbid luminosities, intricate arabesque designs that seem to weave dream-like images.

Moreau was especially interested in the theme of Salomé. He treated the theme as if Salomé were *the Symbolist vision of woman in whom perversity and innocence mix.* Moreau's Salomé is dangerous and destructive, but fascinating. The world that surrounds her darkens and yields under her spell.

Odilon Redon (1840–1916) was an extraordinary engraver and painter of great lyricism who can also be considered a precursor to Surrealism. Redon's works are populated by strange creatures who conjure notions of magic, visions, and fables that each viewer can comprehend in his own way using some subjective key of symbolic interpretation.

Redon's work, despite its high chromaticism, maintains a balance between the bold chromatic contrasts. It was highly regarded by the Nabis. Works like *The Sphinx, The Birth of Venus, Flowers of Evil, Woman and Flowers,* reflect the literary content of Redon's works.

Gustave Moreau, Salome's Dance (circa 1876). Oil on canvas, 60 × 92 cm. Moreau Museum, Paris. Moreau's painting has a clear literary intent.

Odilon Redon. The Red Sphinx (1912–1913). Oil on canvas, 49.5 × 61 cm. Private Collection, Switzerland. Redon's work is populated by strange creatures and apparitions that presage Surrealism.

Pierre Puvis de Chavannes. The Poor Fisherman (1881). Oil on canvas, 155 × 192 cm. Louvre Museum, Paris. This painting displays a peculiar symbolic form for fate, conveyed by the solitary figures that are arrayed in a harmony of barely contrasted flat colors.

The Style of Post-Impressionist Painters
Symbolism of the Nineteenth Century
Evolution and Break. What Is an "Ism"

69

Pierre Puvis de Chavannes (1824–1898) produced works of sober colors and clear tonalities that are highly literary and symbolic in meaning. His painting style was influenced by Giotto.

Aside from his large frescoes, which treat themes from classical antiquity and are intended to evoke an imagined, harmonic, and stable world, Puvis de Chavannes' Symbolism is evident mostly in his easel works. These paintings display beautiful and smooth chromatic harmonies, such as those in his most famous painting, *The Fisherman*. In a tragically melodramatic scene, the artist seems to provide a distinctive symbolism of fate depicted by several characters who simply let time pass and who are integrated into a cold harmony of flat, barely contrasting colors.

Other Manifestations of Symbolism

While Symbolism, as a pictorial movement, is basically French, paintings with similar narrative and allegorical values appear, at the end of the nineteenth century and beginning of the twentieth century, in other culturally and geographically different areas.

Ferdinand Hodler, one of the greatest Swiss painters of modern times (1853–1918) and author of large murals based on historical themes, showed great interest

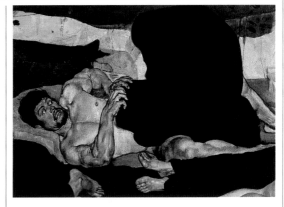

Ferdinand Hodler, Nighttime *(1890).*
Oil on canvas, 196.5 × 116 cm. Art Museum, Bern.
The symbolism of this work conveys a different,
always unsettling, meaning to each viewer.

in the Symbolist movement in works such as *The Dream, Spring,* and *Daytime*. In his interior scene *Nighttime*, for example, the viewer finds depicted on the canvas an allegory of all the fears that night can evoke in the human soul.

Hodler is a painter of robust figures, sober colors, and precise drawings characterized by contours that are strongly reinforced by line tracings.

Isidre Nonell (1873–1911). The paintings of this representative of Catalonian Modernism are clear examples of Symbolist expression within artistic movements outside of French Symbolism.

Nonell made one of the best and most original contributions to Modernist Spanish painting. Aside from some landscapes and a few still lifes, his work centers around his *gypsies*, figures who stand alone, divorced of all relationships to things or people. They carry, within themselves, the symbol of marginalization, interior wounds, depression without possibility for recovery. Nonell's figures are painted in a very personal style, with tidy brushstrokes that weave a very rich pictorial surface of tragic hues.

Isidre Nonell. The Unfortunate Ones *or* Misery *(1904).*
Oil on canvas, 100 × 75 cm. Museum of Modern Art, Barcelona.
Catalonian Modernism produced figures like Isidre Nonell
whose works continue in the Symbolist tradition.

EVOLUTION AND BREAK. WHAT IS AN "ISM"

If we think, for example, about how the female figure has been portrayed in different historical periods, it's easy to see that before the second half of the nineteenth century the differences point to an evolution that never abandoned the naturalistic idea of painting understood as the free imitation of nature. The first three figures broadly represent this evolutionary process. However, when we compare Figure 2 with Figure 3, which belongs to the last quarter of the nineteenth century, we not only compare two periods of art but two completely different ways of understanding painting. It is at this breaking point that we begin to speak historically about "isms." *"Ism" is any innovation that makes a total break with previously accepted concepts in art*, when individual or collective ideas becomes artistic vanguard trends.

1 2 3

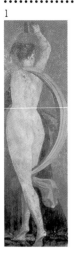
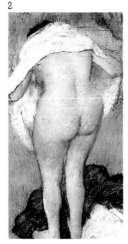
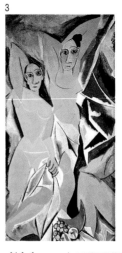

In the Hellenist Pompeian nude (1) and Degas' nude dating from the end of the nineteenth century (2), one discerns an uninterrupted evolution in the naturalistic interpretation of the female body. However, we note a clear break with the traditional way of understanding art between the second sample and the Picasso figures (3).

Antecedents

Heirs to Post-Impressionism and Symbolism, Nabism and Fauvism were the first "isms" characterized by a cult of freedom of expression and, especially, the exaltation of color. However, Nabi and Fauvist ideas, when they assumed these names, were not totally new. The Nabis and Fauvists looked mainly to the Post-Impressionists for their inspiration.

El Greco

El Greco's works, when viewed within the context of Spanish Renaissance that glorified color, display bold color innovations in which artificial chromatic juxtapositions of complementary colors combine to yield a great impact. This characteristic is evident in his great composition *The* *Trinity*, a work in which the contrasts between yellows and blues, though not sharp, can be viewed as prophetic of Fauvism.

Cézanne's Mont Sainte-Victoire

At the end of the nineteenth century, the great Cézanne to whom modern art owes so many innovations thanks to his study of color and form, painted several paintings that emphasized freedom in the use of color for color's sake—a formula that broke with tradition. We note in Cézanne's painting *The Bathers*, in more intimate works such as the *Portrait of Mme. Cézanne* and, clearly in his different versions of Mont Sainte-Victoire, pictorial ideas that give color a predominant role. These ideas will be developed further a few years later in Nabism and, especially, Fauvism.

Main Ideas

• Before Impressionism, new ways of understanding painting emerged as a result of an uninterrupted evolutionary process. From this process new accepted trends emerged during an extended period of time that we call an *epoch*.

• An "ism" is not the result of an evolutionary process, but represents a break with previously established norms.

• The first "isms" of the twentieth century were Nabism and Fauvism, which represented a break with traditional painting in that color was the defining element of a painting and could be applied with no concern for the real color of objects.

• Hints of Nabism and Fauvism are found in very different epochs, but mainly in the Post-Impressionist period.

Symbolism of the Nineteenth Century
Evolution and Break. What Is an "Ism"
Nabism and Fauvism

71

Paul Cézanne.
Mont Sainte-Victoire *(1898).*
Oil on canvas, 99 × 78.1 cm.
Hermitage Museum, St. Petersburg.

Van Gogh, a Fauvist Before the Fauvists

Van Gogh, who chronologically belongs to the group of Post-Impressionists, was one of the painters most admired by the Nabis and Fauvists. This is quite logical because several of the artist's most famous paintings fully reflect the aesthetic ideas of Fauvism. The daring impastos, the vibrating brushstrokes, and the apparent absurdity of the colors (which in van Gogh should be interpreted more an exaggeration of personal symbolisms than a total alteration of real colors) are very close to Fauvism.

Two examples, from the many we could consider, are sufficient to describe the affinity of this Post-Impressionist painter with the fundamental notions of Fauvism: *July Fourteenth in Paris,* an exuberant colorist demonstration, and the genial interpretation of a nighttime landscape, *Starry Night.*

Vincent van Gogh,
Starry Night, *detail.*
Oil on canvas, 92 × 73 cm.
Museum of Modern Art, New York.

Gauguin's *Christ*

Historical Fauvism with its exaggerated studies in the use of color begins in 1905. However, as we look at Gauguin's *Yellow Christ,* painted in 1889, can anyone say that the work is not absolutely revolutionary in its use of color? The contrasts, the unreal colors of the vegetation (furiously red trees) and figures (shapes implied through contrasts of yellows and greens) could be the work of the most dedicated Nabis or, if we move ahead a few years, of any Fauvist.

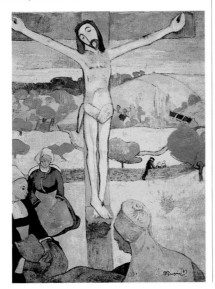

Paul Gauguin.
The Yellow
Christ *(1889).*
Oil on canvas,
78 × 92.5 cm.
Albright-Knox
Gallery of Art.
Buffalo,
New York.

NABISM AND FAUVISM

Toward 1902, a social yearning for modernity strongly influenced art and contributed to its break with the past. Several of the first revolutionary artists called themselves *Nabis*, a Hebrew word that means prophets. These artists produced the first vanguard paintings of the twentieth century, which were characterized by total freedom in composition and color. And although each Nabi preserved his own style, they all worked under a more or less common ideology that held that a *painting is essentially nothing more than a flat surface covered with color*. For the Nabi, everything else was incidental. Freedom in the application of color was carried to the extreme by a group of artists who exhibited their works at the 1903 Fall Salon in Paris. Their paintings were a fury of colors that bore little or no resemblance to the real colors of objects. The works prompted one critic to call the artists *fauves* or beasts. The Fauvist label stuck as the term used to designate the paintings produced in the early years of the twentieth century, distinguished by what we might call an explosion of color.

Pierre Bonnard.
The Window *(1925). Oil on canvas. Tate Gallery, London.*

Édouard Vuillard (1868–1940) is another important French Nabi artist. He was a close friend of Bonnard's and an enthusiastic follower of the same aesthetic ideas,

as his interior scene with figures, *The Princess Bibesco*, illustrates. In his search for aesthetic expression, Vuillard interprets forms with great simplicity, outlining them with fine lines and modeling them with subtle chromatic contrasts in a manner reminiscent of Gauguin's concrete style.

The Style of the Historical Nabis
Pierre Bonnard (1867–1947)

Bonnard, considered the first Nabi, rejected the painting styles of his time, beginning with Impressionism, and opted for very clean, generally light colors. These he applied harmoniously within the outline of sketchy drawings and with almost imperceptible chiaroscuros resulting from a lack of sharp contrasts. His favorite themes are interior and outdoor family scenes and nudes executed with great simplicity and without compositional complexity. We can say that Bonnard's style marks the turning point between Impressionism and the unrestrained chromaticism of the Fauvists.

Édouard Vuillard.
The Princess Bibesco *(1912). Oil on canvas, 81 × 112 cm. São Paulo Museum of Art.*

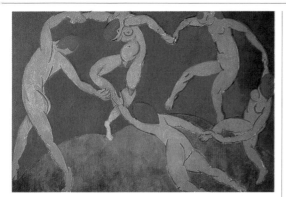

Main Ideas

• The Nabi style draws on Gauguin's ideas, which held that color in art need not duplicate nature's.
• Nabism and Fauvism are a legacy of Post-Impressionism.
• The Fauvists challenged the idea that nature should be represented with "authentic" colors that correspond to reality. Instead, they used strident, discrepant, and apparently absurd color in portraying it.
• Matisse, Derain, Vlaminck, and Dufy were the most representative figures of Fauvism.

Famous Fauvists and Their Style

Henry Matisse (1869–1954) is, without doubt, the most important representative of Fauvism, a genre with which he was identified after a gradual stylistic evolution. Matisse's drawings are characterized by austere and simple tracings (Matisse was an excellent draftsman). Color, which Matisse made his main medium of ex-pression, became the dominant element in his paintings.

His paintings, *The Dances* (1909) and *The Pink Nude*, embody Matisse's Fauvist style: rhythms and forms produced through simple and direct drawings and practically flat, contrasting, complementary colors.

André Derain (1880–1954) was one of the many young painters who followed in Matisse's

Henri Matisse. The Dance *(1910). Oil on canvas, 288 × 260 cm. Hermitage Museum, St. Petersburg.*

footsteps. Several of Derain's works can be considered stylistic models of Fauvism because of the artist's unbridled use of color and strong contrasts and, especially, his emphasis on extravagant hues. His paintings show a good understanding of color theory and utter disregard for the factual. Derain's work, *The Westminster Bridge*, is one of the best examples of Fauvist painting.

Maurice Vlaminck (1876–1958) was a Fauvist whose style is characterized by the use of large impastos that fill the entire pictorial surface, by thick multidirectional brushwork, and by shapes outlined in black. The unorthodox and strident colors round out the Fauvist tone in his works. As his paintings clearly show (*Houses of Chatou*, for example), Vlaminck was influenced by Gauguin and

van Gogh, though later he espoused the constructivism championed by Cézanne.

Raoul Dufy (1877–1953), French painter, is one of those artists whose works are difficult to classify because of the frequent changes he made to his style throughout his lifetime. In his Fauvist phase, his most outstanding period, which spanned the years 1905 to 1908, he demonstrated skill and sensitivity in oils and watercolors without relying on extreme chromatic virulence such as, for example, we find in Derain's works. Beginning in 1906, Dufy moved away from Fauvism, which was still in vogue at the time, and developed his own individual style characterized by delicate and imaginative designs, succinct and brisk graphics, and a remarkably fresh color scheme highlighting blues.

André Derain. The Westminster Bridge. *Oil on canvas, Private Collection, Paris.*

Maurice Vlaminck. Houses of Chatou *(1905–1906). Oil on canvas, 100 × 82.5 cm. Art Institute of Chicago.*

CUBIST PAINTING. WHAT IS CUBISM. ANALYTICAL CUBISM

At the turn of the twentieth century, the Cubist revolution broke completely with the traditional concept of *pictorial space* based on perspective as it was defined by Brunelleschi and the Florentine artists of the fifteenth century. The originality of Cubism lies in the artist's pictorial approach to his model. When executing a painting, the artist views the painted object from different angles and then combines these views in the same pictorial space.

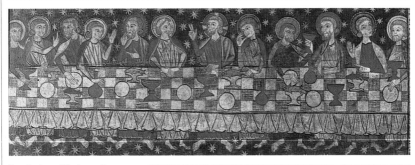

Frontispiece of Soriguerola (thirteenth century), detail from the Last Supper. Catalonia Museum of Art, Barcelona.

Cubist Solutions Before Cubism

Romantic painting (which did not recognize perspective) is laden with examples in which shapes of objects are treated in ways quite similar to the Cubist technique. For example, in the Last Supper of the so-called *Frontispiece of Soriguerola* (Catalonia Museum of Art), the figures, the table, and the objects on it are portrayed in a way that suggests that the artist moved around in order to view each element from the best vantage point so as to portray its shape. The figures, glasses, and jugs appear as if painted from a high frontal perspective, while the plates and square tablecloth are viewed straight-on.

Picasso's First Cubism. *Horta d'Ebre Factory*

In this 1909 painting dating from Picasso's early Cubism, the buildings, palm trees, and mountains are fragmented (since they are viewed from different angles) into facets that display their own light effects. The background and

various elements in the painting are brought together in the same plane to highlight the primacy of the pictorial surface that combines the disparate views. This treatment illustrates the "medieval flavor" of early Cubism.

Main Ideas

• Disregarding traditional perspective from a single focal point, Cubism deals with the complexity of visual sensations by portraying objects that are viewed simultaneously from different angles.
• In Analytical Cubism, the artist focuses on the disintegration of forms into small facets.

Pablo Picasso. Horta d'Ebre Factory (1909). Oil on canvas, 60 × 53 cm. Hermitage Museum, St. Petersburg.

Analytical Cubism

Early Cubism, called Analytical Cubism, is based on a geometric analysis of forms and space. Forms are broken down into multiple facets and painted with short brushstrokes that make them appear as gray and ocher crystal shapes.

The analysis, however, is not based on a scientific method, but on skill and intuition. The Cubists were not scientists, they were artists. Picasso once said: "I don't look for things, I find them."

Pablo Picasso. Portrait of Ambroise Vollard *(1911).* Oil on canvas, 65 × 92 cm. Pushkin Museum, Moscow.

Important Works of Analytical Cubism

In Picasso's *Portrait of Ambroise Vollard*, painted in 1911, we observe the main characteristics of Analytical Cubism: use of a sober palette and orderly integration of form and space onto the pictorial plane. We can see how each facet, arising from multiple and simultaneous viewings of the model, is illuminated separately. Breaking with the convention of viewing the model from a single point in space also, logically, implies breaking with the convention of a single light source required by classical chiaroscuro techniques.

Together with Picasso, George Braque (1882–1963) fathered Cubism. The style first appeared in works such as *Le Guéridon*, which Braque painted in 1912. A violin and some musical scores, placed on top of (or around) a chair, are the subject of this "Cubist reality," which consists of multiple fragments of multiple views that are rendered in a remarkably terse manner. Braque's colors are always sober and show little contrast. In almost all of his works, Braque tends to use a warm monochromatic palette and always uses lines as structural elements.

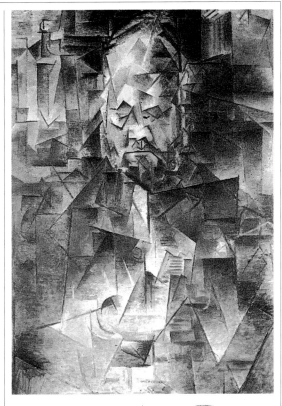

Numbers and Letters in Cubist Paintings

Still lifes are among the most preferred themes in Cubism. The themes generally deal with Cubist interpretations of objects with which the artist comes into contact in his daily life. Bottles of wine, glasses, pipes, newspapers, and musical instruments are the subject of several of the most famous Cubist paintings.

In works such as *Violin, Glass and Pipe on a Table* (1912), Picasso introduced the idea of incorporating numbers and letters into a Cubist painting. From an aesthetic point of view, these elements represent the counterpoint that an *unfractured object* contributes to the universe of a world composed of *disintegrated parts.*

Pablo Picasso.
Violin, Glass and Pipe on a Table
*(1912), Oil on canvas, 54 × 81 cm.
National Gallery, Prague.*

Georges Braque.
Le Guéridon. *(1912).*
Oil on canvas, 81 × 115 cm.
Museum of Modern Art, Paris.

COLLAGE AND *PAPIER COLLÉ*

Around 1913, several Cubist painters broke with tradition and developed a new technique called *collage* or *papier collé* (pasted paper), which complemented (or was complemented by) the painted portion of the work, and consisted in the integration of pasted objects and papers onto the artwork. Picasso, Braque, Gris, and others demonstrated how a piece of alien material, something which under ordinary circumstances would have no connection to painting, could become a pictorial element when used in one of two ways:

• Using cutout pieces of paper as pictorial materials in structuring planes of color and suggesting shapes of objects.

• Transferring whole sheets of paper to the painting (the paper was not used in modeling different objects but was intended to retain its look as a paper sheet).

- -

Georges Braque.
Glass, Bottle, and Newspaper.
Papier collé, 28 × 62.5 cm.
Private Collection, Brasilia.

Pablo Picasso.
Guitar and Glass *(1913).*
Papier collé, 36.5 × 48 cm.
Marion Klooger Institute,
San Antonio, Texas.

Main Ideas

• Collage or *papier collé* is a technique that attains pictorial effects with materials pasted onto the surface of the painting.
• The practice of collage was one of the factors that led to the emergence of Synthetic Cubism.
• In Synthetic Cubism, small facets disappear and are replaced by larger geometric figures.

that is a clear example of his personal Cubist style. The multiple perspectives the object is viewed from, underside views, raised front and side views, and their juxtapositions blend together as a fused mosaic.

While remaining faithful to Cubist ideas on how to interpret form, Juan Gris did not reject the aesthetic value of color, as evident in the above-mentioned work. There, color, which is organized

An Example of the First Technique is Picasso's *Guitar and Glass* (1913).

Here Picasso uses pieces of paper as a pictorial medium and interprets forms by using the colored paper cutouts to suggest them.

An Example of the Second Technique. Braque's painting *Glass, Bottle and Newspaper* is a composition in which each pasted piece of paper stands for what it is: a piece of paper. The addition of several sepia-colored strips of paper provide greater pictorial vibrations to the artist's *papier collé* creation.

A Spanish Cubist Known as Juan Gris

The third painter considered as one of the great trio of Cubists was the Spaniard José Victoriano González (1887–1927), known in the art world by the pseudonym of Juan Gris.

He was a highly original artist who structured his compositions within a linear grid. In *The Washstand*, which he painted in 1912, he combines the techniques of oil painting and collage in a work

Juan Gris. The Washstand *(1912).*
Oil and mirror pasted on canvas,
89 × 130 cm. Private Collection, Paris.

Cubist Painting. What Is Cubism
Collage and *Papier Collé*
Expressionism Before the Twentieth Century

77

Juan Gris. Bottle of Anisette
*(1914). Papier collé, oil, and
graphite, 24 × 41 cm.
Judith Rothschild Collection.*

character) and in the composition of the work. A good example is *Mars' Field with the Red Eiffel Tower*, a work he did in 1911.

Synthetic Cubism

The search for novel forms of expression in collage art led Cubist artists to break down collage materials into smaller parts and to consider the plastic possibilities of diverse materials in their compositions. As a result, a new phase of Cubism, known as Synthetic Cubism, evolved. Rather than interpreting real forms as a whole

of parts viewed simultaneously from differing perspectives, Synthetic Cubism studies real forms in pieces, each piece occupying the appropriate place that gives a Cubist interpretation to reality.

The most important work of Synthetic Cubism is Picasso's painting *Three Musicians*, of 1921. Here Picasso concentrates more on assembling irregular pieces of an imagined reality than on producing a work consistent with the idea of multiple points of view. However, the painting is clearly Cubist in that there is disintegration and subject and space are continuous and flat.

*Robert Delaunay.
Mars' Field with the Red
Eiffel Tower (1911).
Oil on canvas, 140 × 200 cm.
Art Institute of Chicago.*

in concrete planes within the composition, adds a chromatic balance, thanks to several artfully chosen warm and cool contrasts, to the compositional balance of the work.

Juan Gris and Collage

Gris was a masterful collage artist whose Cubist artwork relied on pasted or painted surfaces with attractive colors and textures. His creative techniques are exemplified in his small 1914 collage entitled *Bottle of Anisette* (24 × 41.8 cm). Here he presents a flat disintegration of a bottle of anisette based on partial images of it.

Cubism of Robert Delaunay

The style of Robert Delaunay (1885–1941), which was called *Orfism*, leaned towards entirely abstract forms. Inspired initially by Fauvism, Delauney eventually embraced Cubism. The originality of Delaunay's Cubism, less rigid than Analytical Cubism, is seen in his space rendition of depth perspectives through the treatment of color (which never lost its Fauvist

*Pablo Picasso.
Three Musicians (1921).
Oil on canvas, 188 × 204 cm.
Philadelphia Museum of Art.*

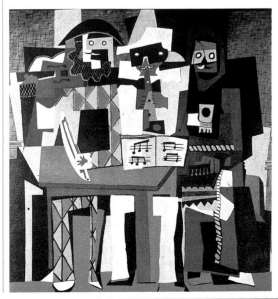

EXPRESSIONISM BEFORE THE TWENTIETH CENTURY

In a broad sense, the term Expressionism is used to denote works of art of very different epochs that articulate an emotional state, anxiety, and inner conflict—as if artists were compelled to release their inner tensions in dramatic fashion.
Examining works from different epochs that fall in this category helps us realize that *distortion of color and form is the most important characteristic of Expressionist works*, and that Expressionism appears in periods of personal crisis or of social, political, ethical tensions. It is not a coincidence that artists such as Bosch, van Gogh, El Greco, and Goya were favorite painters of the Expressionists of the twentieth century.

Hieronymus Bosch. Christ with Cross, *detail.*
Oil on board, 151.5 × 195.5 cm. Museum of Fine Art, Gante.
The caricatured faces express human stupidity and cruelty.

Pen Drawings (1499) by Leonardo da Vinci

In one of his *Anatomy Notebooks*, the Renaissance artist has sketched several studies of human expressions with firm and vibrating strokes. In his search for genuine Expressionist exaggeration, the drawings stand out as pathetic caricatures of human fervor and emotions reflecting pain, anger, foolishness, stupidity.

Though they are not paintings, we have included here the example of the drawings to show how Expressionism, as a manifestation of inner tension, can materialize in any historical period when artists want to represent emotional states.

Leonardo da Vinci.
Pen Drawing *(1499),*
from Anatomy Notebooks.
Royal Windsor Collection.
Leonardo exteriorizes human emotions and sensations through grotesque faces depicted in an Expressionist style.

Expressionist Examples Before the Twentieth Century

Christ with Cross (detail) by Hieronymus Bosch (Hieronymus van Acken, 1450–1516). The works of this highly original Flemish painter clearly demonstrate the Expressionist tendency of a past epoch. For Bosch, as for Expressionists in all ages, any profane or religious theme is an excuse for venting internal conflicts or for denouncing behaviors through caricatured faces, grandiloquent gestures, or the depiction of tragic scenes. The distortion seen in the detail of the abovementioned work expresses and universalizes human stupidity and cruelty.

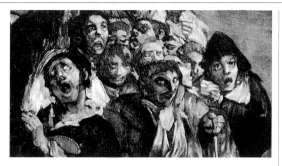

Franscisco Goya. The Pilgrimage of San Isidro, *detail.*
Mural painting transferred to canvas, 438 × 140 cm. Prado Museum, Madrid.

The Pilgrimage of San Isidro

Goya is undoubtedly the foremost predecessor of pictorial Expressionism. A liberal among absolutists, his internal crises manifest themselves in paintings that are at times hallucinatory and that reflect unparalleled levels of sarcasm, irony, and drama. It's enough to study the faces of the San Isidro pilgrims, with their distorted features and the tragic atmosphere that engulfs them (which the artist renders with rotund impastos of color) to recognize the essential elements of the Expressionist movement that would emerge a century and a half later. This painting by Goya, which is unlike one expected from a court painter, seems to be a reflection of the painter's thoughtful commentary "when reason sleeps, monsters awake."

Self-Portrait by van Gogh

We have seen that the peculiar characteristics of van Gogh's works are undeniably connected to the "isms" of the twentieth century, among which is Expressionism. Reading his biography it is easy to understand that, given his inner conflict and continued failures, Expressionist elements would be a constant part of his works. This self-portrait, painted with a tormented brush and in irrational colors, embodies all of the anguish, poverty, and desperation of the genial madman.

Main Ideas

• Expressionist works represent an aesthetic manifestation of the artist's state of mind and convey personal or general feelings such as sarcasm, anguish, fear, and desperation.
• Expressionism leads to exaggeration in both color and form.
• The Expressionist tendency appears in periods of personal crisis for painters, such as crises associated with social tensions and breaks in ethical values.

Vincent van Gogh.
Self-Portrait, *detail.*
Oil on canvas, 37.5 × 44 cm.
Van Gogh Museum, Amsterdam.

Life (1903–1904) by Pablo Picasso

In one of Picasso's "periods," called the blue period, the artist shows a clear Expressionist tendency. The suicide of his friend Casagemas in 1901 prompted a shift in his works that reflected expressions of meditations on the meaning of life. Misery, loneliness, melancholy characterize a long series of paintings that have in common a monochromatic coolness in which blue is the predominant color. In paintings such as *Life*, the unsettling quality of a dreamlike nighttime and the distorted and angular qualities of the figures reflect a high degree of subjectivism, which forebodes the future European Expressionism.

Pablo Picasso. Life
(1903–1904), fragment.
Oil on canvas, 127.3 × 197 cm.
Cleveland Museum of Art.
The distorted, angular shapes of these figures in the painting give them a clear Expressionist quality.

EXPRESSIONISM AS AN "ISM" OF OUR CENTURY

In the so-called "ism era" of modern art, the term Expressionism is applied to the movement that emerged in Europe, particularly in German-speaking countries, during the first quarter of the twentieth century. German Expressionism reflects an inner visionary interpretation of man and the world in rebellion against the moral codes of a society which, while undergoing rapid industrialization, still clung to the dictates of an archaic mentality.

James Ensor. Old Woman with Masks *(1889).* Oil on canvas, 74 × 54 cm. Museum of Fine Arts, Gante.

Edvard Munch. The Scream *(1893). Oil and tempera on cardboard, 73.5 × 89 cm. Municipal Gallery of Arts, Oslo.*

Expressionist Artists and Styles

James Ensor (1860–1949), a Belgian painter, is considered one of the precursors of modern Expressionism. His work is characterized by a strong obsession for what we might call "the masquerade of life," a reflection, perhaps, of an unhappy childhood spent under the tents of a traveling circus owned by his father. Ensor paints with lively colors, soft washes, and thick impastos that enhance the quality of his works.

Edvard Munch (1863–1944), a Swiss artist, is considered the founder of modern Expressionism. In works such as *Puberty, The Sick Girl, The Death Bed,* and *The Scream*, he expresses an inner world full of nostalgia, fear, and desperation.

The Scream, painted in 1893, is one of the most important works of Expressionism. The turmoil exposed by his brushwork and color treatment, which exhibits Nabi and Fauvist influences, are plastic manifestations of inner strife. Violent colors, whirling rhythms, and dramatic perspectives highlight the very desperate ghost-like character in the foreground.

Oscar Kokoschka (1886–1980). This Austrian artist is one of the truest Expressionist painters of his time and one of the most distinguished of the twentieth century. In his hallucinatory paintings, Kokoschka uses thick impastos and twisting brushwork to achieve bright and unsettling textures and contrasts, a style that lends itself well to the type of portraits he paints. In these portraits, Kokoschka depicts people who, beneath their outer surface, hide a frightening inner Freudian world in turmoil (in reality, the anguished world of the painter himself).

Main Ideas

• Twentieth-century Expressionism is a poignant art.
• Expressionism is not a style or school, but a tendency.
• Expressionist painting is usually characterized by thick brushstrokes and disjoined forms that display strong, at times Fauvist-like, colors.
• Expressionist compositions tend to be bewildering and unbalanced.
• All of twentieth-century art is full of Expressionist manifestations in different styles.

Expressionism Before the Twentieth Century
Expressionism as an "Ism" of Our Century
Movement in Painting and Futurism

81

Egon Schiele (1890–1918) is another Austrian who belongs to the group of unmistakable Expressionist painters. In his drawings and watercolors, which generally deal with the theme of the female nude, his figures are always tense, angular, and extremely tortured. The obsessive erotic traits Schiele often displayed in his nudes caused him considerable problems and eventually led to his incarceration.

George Roualt (1871–1958) is the leading representative of French Expressionism. All of Roualt's works, both religious and profane, depict the aesthetic expression of an individual with deep respect for human values. His Expressionist style relies on sweeping brushstrokes, intense colors, and simple compositions.

Marc Chagall (1887–1985). The works of this Russian painter of Jewish parentage transcend the confines of reality. Despite their Surrealistic appearance, his paintings do not delve in the subconscious or in dreams. Chagall pays homage to his memories as if he wished to project them poetically into the future.

The works Chagall completed during his Expressionist and Surrealist phase are characterized by original and spontaneous designs with pleasing colors. The creative compositions depict childhood memories as forms floating in the air.

Amedeo Modigliani (1884–1920) is an Italian painter who settled in Paris. His style is difficult to define since he was influenced by both Expressionism (as his highly deformed figures indicate) and by the tradition of the Florentine and Venetian Renaissance masters. The touch of classicism that characterizes his unique type of Expressionism is particularly apparent in his female figures whose elongated

Oskar Kokoschka. Friends *(1917–1918), detail. Oil on canvas, 150 × 100 cm. City Gallery, Linz.*

necks and torsos flow into voluptuous hips. Modigliani's bodies have an unreal quality and poetic sensuality, their volumes barely emphasized by very subtle chiaroscuros executed in a pleasing range of warm colors.

Picasso's Post-Cubist Expressionism

The multitalented Pablo Picasso is a good example of how personal and social conflicts can drive an artist to express deep emotions through Expressionist aesthetics. In response to a request from the government of the Spanish Republic to provide a work for the Universal Exhibition of Paris in 1937, the artist painted his famous *Guernica* (large mural rooted in Cubism), inspired by the Spanish Civil War. Taking as a motive the bombing of Guernica by the Condor Legion, Picasso releases a loud universal cry against the cruelty of war.

Egon Schiele. Girl Seated. *(1910). Watercolor and gouache. Albertina Museum, Vienna.*

Amedeo Modigliani. Reclining Nude *(1919). Oil on canvas, 116 × 72.4 cm. Museum of Modern Art, New York.*

MOVEMENT IN PAINTING AND FUTURISM

Artists have always striven to capture figures in motion. However, what artists have been able to achieve in art throughout the ages has merely been *to capture and freeze an instant of motion*. It wasn't until the twentieth century that, with the proclamation of the Futurist Manifesto, that motion (actually, the concept of motion) became a topic of paintings that relied on the visual principles held by Cubism. *When Futurist painting tries to portray motion, it does not intend to capture "an object in motion," but rather "the motion of an object."* Futurist painting is identified with motion, speed, the machine, energy, and violence, which become the real essence of the painting. Whether the item in motion is a person or a machine is immaterial; what the Futurist painter considers an artistically worthwhile topic to portray is the abstract concept of motion itself, its vigor and dynamism captured not just at a particular instant of time, but in an infinite number of sequentially repeated instants.

Umberto Boccioni (1882–1916).
The Dynamism of a Cyclist *(1913).*
Oil on canvas, 95 × 70 cm.
Private Collection, Milan.

Motion in Futurism. Artists and Works

The Dynamism of a Cyclist, by Umberto Boccioni, is one of the first Futurist paintings that exalt the idea of motion. Futurist art relied on Impressionist theories of color and the Cubist principles of simultaneous viewings to represent form and space and to express dynamic ideas. In Boccioni's painting (1913), the Cubist influence and the artist's cognizance of color theories are quite evident. Even more manifest, however, is his portrayal of straight and curved dynamic rhythms that link together several fleeting instants of motion.

Abstract Speed (an Automobile Has Passed) by Giacomo Balla (1871–1958). Before his inquiries into metaphysics, Balla was interested in the abstract aspects of Futurism, namely, the implication of motion and dynamics and not their representative form.

In Balla's work, force and motion are suggested through abstract physico-mathematic concepts (vectors, force fields, trajectories, etc.).

Funeral Rites of the Anarchist Galli, by Carlo Carrá (1881–1966). Carrá's works are Futurist, yet they do not completely forsake representative form. In this disjointed composition of barely distinguishable shapes, opposing diagonals hint at violent excitement, while the repetition of trajectory curves suggest motion. The combination of subtle tonal contrasts highlight the focal centers of interest. Converging diagonals and rhythmic curves provide direction to motion and coherence to the composition.

The Dynamic Hieroglyphics of the Dancer of Tabarin, by Gino

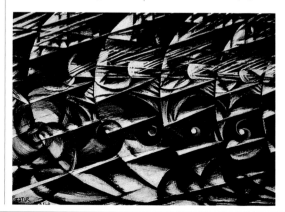

Giacomo Balla.
Abstract Speed
(an Automobile Has Passed) *(1913).*
Oil on canvas, 108 × 78 cm.
Private Collection.

Expressionism as an "Ism" of Our Century
Movement in Painting and Futurism
Metaphysical Painting
83

Carlo Carrá. Funeral Rites of the Anarchist Galli *(1911), fragment. Oil on canvas, 259 × 198 cm. Museum of Modern Art, New York.*

Severini (1883–1960). In the same way that Futurism wished to influence daily life, daily life became a theme for Futurist painters. Several works by Gino Severini illustrate this interest and relate to motion associated with activities as trivial as a dance gathering. These are disjointed compositions suggesting frenetic movement conveyed through a minuscule and utter disintegration of forms and through the application of bright colors in which whites and blacks are balanced by warm and cool shades.

Nude Descending Staircase No. 2, by Marcel Duchamp (1887–1968). Duchamp, whom we will later associate with the Dada movement, was one of the most important painters of the twentieth century. A serious student of art techniques, Duchamp was imbued with Cubist and Futurist ideas that influenced his most original interpretations of form and motion. In his most famous work, *Nude Descending a Staircase*, which he painted in 1912, he portrays in true Cubist style distinct instants in the motion of an image that he calls "the machine figure." The analytical representation of ongoing motion, which he executes in conformity with Cubist visual principles, establishes this work as one belonging to his Futurist stage.

Dynamism of an Automobile, by Luigi Russolo (1885–1947), Museum of Modern Art, Paris. Russolo's style wavers between genuine Futurism, with works that recall Boccioni's treatment of motion, and Symbolism. At the end of his career, Russolo's paintings tended toward a Naïf style.

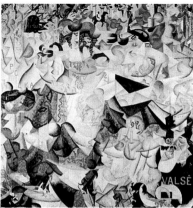

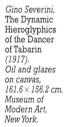

Gino Severini, The Dynamic Hieroglyphics of the Dancer of Tabarin *(1917). Oil and glazes on canvas, 161.6 × 156.2 cm. Museum of Modern Art, New York.*

Main Ideas

• Stylistically, Futurism is rooted in the Cubist theories based on fragmentation of form.

• Ideologically, Futurism is an exaltation of all that is modern and dynamic.

• The onset of Futurism was triggered by the First Futurist Manifesto of 1909, which states: "... the splendor of the world has been enriched by a new beauty: the beauty of speed."

• Futurism is one of the most daring attempts to incorporate art into daily life and impart to it true modern meaning.

Marcel Duchamp. Nude Descending Staircase No. 2 *(1912). Oil on canvas, 89 × 147.5 cm. Philadelphia Museum of Art.*

METAPHYSICAL PAINTING

Metaphysical painting represents an important stage in modern art, not just because of its own merits, but as a precursor to Surrealism. From a stylistic point of view, Metaphysical art breaks away from the dynamic precepts of Futurism and returns to the calm of classicism. From a doctrinal point of view, it is a blossoming of artistic dreams beyond the physical domain. If we had to identify a common characteristic of Metaphysical painting we would say that "*its settings are realms within which imaginary figures and objects that are garnered from reality materialize, albeit from a lifeless reality that is oblivious of its surroundings.*" This dream-like element is present even in landscapes. Columns, puppet-like figures, horses, aberrant ruins, statues, even fruit take on an absent air, like the petrification of a dream or of a forsaken moment.

• •

Giorgio de Chirico, Hector and Andromaca *(1917). Oil on canvas. Mattioli Collection, Milan.*

"Metaphysical" Works and Artists

Hector and Andromaca, by Giorgio de Chirico (1888–1978). Painted in 1917, this work embodies all of the characteristics of Metaphysical painting. The style, which closely follows academic conventions, caters to the unreal and suggests a vision in which dreams and mythology combine in a mysterious chromatic setting. Perspective and color carry us to the depths of a metaphysical world that can materialize only in dreams or hallucinations. Although painted seven years before the so-called Surrealist Manifesto, the style of this painting follows closely that of numerous later date Surrealist works.

Metaphysical Still Life, by Carlo Carrá (1881–1966). After his Futurist stint, Carrá embraced Metaphysical painting in 1916, becoming one of its founders. He painted several still lifes in which diverse objects acquire an unsettling air that is at times radiant and always nightmarish, thanks to color and highly unconventional compositions and a somewhat archaic design. With Chirico, Carrá is considered one of the main precursors of Surrealism, which he anticipates through the depiction of a highly enigmatic dream-like world.

Still Life, by Giorgio Morandi (1890–1964). Morandi is a Metaphysical artist who painted still lifes and landscapes that he endowed with his own metaphysical touch. In Morandi's still lifes, we find absurd objects placed next to others that are commonly represented in most classical still lifes. Though clearly identifiable, the classical still life elements assume an indisputable metaphysical character thanks to the rendition of color and light and, especially, to a highly equivocal perspective. The perspective prompts forms to appear concave and convex at the same time, as if they were entrapped in an alien fantasy.

The Metaphysical Style of the *Neue Sachlichkeit*

When discussing Metaphysical art in painting, the German movement called *Neue Sachlichkeit* (New Objectivity) also deserves mention. Although the artists in this movement display

Carlo Carrá.
Metaphysical Still Life *(1919). Oil on canvas, 50.5 × 45.5 cm. Private Collection, Milan.*

Giorgio Morandi.
Still Life (1918).
Oil on canvas, 47 × 56.5 cm.
Pinacotecha Brera, Milan.

Dada influences, their works also incorporate clear Metaphysical elements such as puppet-like and caricature-like figures that appear to emerge from a dream world.

Untitled, by George Grosz (1893–1959). Grosz, one of the most prominent representatives of the *Neue Sachlichkeit*, adopted many elements from Metaphysical painting like, for example, the haunting puppet-like figures that symbolized the anonymous nature of social relations and the authoritative character of the upper class. Although he was part of the Dadaist group of post-war Berlin, many of Grosz's works such as his *Street Scene*, in which he decried the social customs of his time, belong to the aesthetic of the New Objectivity and can be, therefore, classified as Metaphysical art.

The Painting of Henri Rousseau

Henri Rousseau (1844–1910), is another painter whose works are difficult to classify. We include him in this section devoted to Metaphysical painting simply because he is a painter who, at the beginning of the twentieth century, created an unmistakable style that portrayed a world which, through its unreality and mystery, is reminiscent of the dream-like qualities of Metaphysical painting. Rousseau paints in a

detailed academic manner. However, because of the infantile look of his figures, his style was labeled *naïf* (naive). The Cubists considered Rousseau's style to be a break with tradition, much as theirs was. In his painting, *The*

George Grosz. Untitled (1920).
Oil on canvas, 61.3 × 81.3 cm.
North Westfalia Art Collection, Düsseldorf.

Snake Charmer, which is found at the Museé d'Orsay in Paris, Rousseau displays his knowledge of flora in an extraordinarily imaginative composition that shows little concern for technique but that possess the charm and sincerity that sets *naïf* painting apart.

Henri Rousseau.
The Snake
Charmer (1907).
Oil on canvas,
189 × 167 cm.
Museé d'Orsay,
Paris.

DADA PAINTING OR DADAISM

To say "no" to everything, to rebel against everything, came to be the ideological principles of the artists who called themselves Dada. They categorically denounced a civilization (including its art) that, after all, had been capable of declaring wars that could lead to the destruction of the world. The Dada movement was born in 1916 and had as its ideological leader the Romanian poet Tristan Tzara who, when searching with a group of friends for a name to give to their totally anarchical "anti-everything" movement, decided to open a French dictionary and select the first word they saw. This word was Dada, a word that bore no relation to art. In reality, Dadaism is a paradox because, while its members claimed to deny everything, they couldn't deny themselves and had to assert the reality of their beliefs despite presenting them as "anti-art." A number of major and eminent artists belonged to the Dada movement, among whom were Marcel Duchamp, Francis Picabia, and Hans Arp.

Representatives of Dadaism

Hans Arp (1887–1966). Although better known as a sculptor than a painter, Arp produced, during the first World War, numerous paintings with a distinct Dada character in their freedom of execution and anti-conventionalism.

Portrait of Tristan Tzara (1916) and the *Table with Eggs* (1922) are two of Arp's abstract compositions produced with planks of painted wood. Any casual onlooker can deem these works as incidental developments of an idea or of an initial model that then spontaneously evolved, keeping the necessary balance and harmony required by art compositions.

Arp experimented with different materials (wood, ropes, paper), making collages and painted reliefs that, despite their abstract nature, suggest live and dynamic forms.

Marcel Duchamp and Dadaism

Following a bout with Futurism, Duchamp eventually embraced the Dada ideas and produced numerous paintings and other truly provocative art forms. In painting, Duchamp wavered between Cubist disintegration themes and the theme of "the machine." This latter theme, a symbol of anti-art, had as its exclusive purpose the obliteration of the concept of "work of art." The machine becomes a

product of fantasy, an expression of contradictions and, even more, of paranoia stances. Paranoiac demeanor led Duchamp to propose multiple meanings for common objects such as a chocolate mill.

Marcel Duchamp. La Mariée Mise à Nu par ses Celibataires, Même (Gran Verre) *(1915–1923). Oil, varnish, metal, thread, and granules of lead, mounted on two pieces of split glass. Philadelphia Museum of Art.*

Hans Arp. Portrait of Tristan Tzara *(1916). Wood painted with oil, 49 × 47 x 9 cm. Thyssen-Bornemisza Collection.*

La Mariée Mise à Nu par ses Celibataires, Même (Gran Verre)

This large painting (2.70 × 1.70 m) is, without doubt, one of the most enigmatic works of all contemporary art. Duchamp composed it using an absolutely anti-conventional blend of techniques (oil, varnish, lead, thread, dust …) mounted on an unusual support: two pieces of split glass. The author designates the top piece to represent the "Bride" and the bottom one the "Bachelors," giving them machine-like forms

Francis Picabia. Voilà la fille née sans mère. *Gouache and oil on paper, 65 × 50 cm. Private Collection.*

This strongly politicized activity was centered around the Dada Club of Berlin and in artists like Schwitters. Schwitters did not assign names to his paintings based on their subject matter; rather he referred to them by the name of *Merz*, a word taken from the German word *Comerzbank*. He used *Merz* to preface the titles of his works (*Merzbil A1*, for example). In his *Merzcollages*, collages he produced with waste materials, one notes a certain allusion to "the Dada machine," even though the collage materials and their textures remain the main focus of the works. The most outstanding works of Schwitters are his enormous collages titled *Merzbaus* or *Columns*.

(whose function he described in his notebooks) and clashing symbolisms.

The Dada Machines of Picabia

Within the Dada movement, the Frenchman Francis Picabia (1879–1953) stands out for his paintings that portray mechanical structures that are, at times, highly technical and, at other times, totally absurd. Picabia's compositions are conditioned by the machines he creates or invents. In other words, he substitutes classical composition with a display of the machine's various components. "*The composition is the machine and the machine conditions the composition.*" The composition cannot change unless the machine stops working. Picabia's works convey, nonetheless, a strong feeling of balance.

The Dada absurdity leads him, as it did Duchamp, to identify his machines with ideas related to human life.

German Dadaism. Kurt Schwitters (1887–1948)

The period between the two world wars was characterized by intense Dada activity in Germany.

Kurt Schwitters. Merzbil A1, the Psychiatrist *(1919). Oil on canvas and collage, 38.5 × 48.5 cm. Thyssen-Bornemisza Collection, Lugano.*

Main Ideas

• The name Dada has no particular meaning but represents the most anarchical artistic movement of the period between the two world wars.
• Dada anarchism leads to the introduction of machines and mechanical parts (representing anti-art) as a form of plastic expression.

THE SURREALIST TENDENCY

In every epoch, art's purpose has been to evoke a world where dream recollections, nightmares, and fears of afterlife can flourish. Let's remember, for example, Bosch's *Garden of Earthly Delights*, and Goya's *Black Paintings*.

Surrealism has its origin in the Surrealist Manifesto of André Breton (1896–1966) which he issued in 1924. Breton, a poet and psychiatrist, was very familiar with Freud's work whose psychoanalytical theories opened unforeseen possibilities in painting. It is not by accident that the subconscious manifests itself through mental images.

But, despite the relevance of Freudian theories on dreams, Surrealist painting did not formulate a set of formal precepts or aesthetic axioms. Surrealist painters were not psychiatrists; they were artists with individual imagination and fantasy.

The Surrealist Painting of Max Ernst

The French painter of German origin Max Ernst (1891–1876) was originally a Dadaist who, after 1922, became one of the major representatives of Surrealism and used *frottage*, a technique of designing by rubbing (as with a pencil) over an object placed underneath the paper, and which led to subconscious creation.

In his series *Histoire Naturelle*, the stains Ernst skillfully achieved through his use of frottage led him to portray a mysterious world whose lavish flora turns, at times, into insects and fictitious animals, thereby creating a world where the horrible combines with the fantastic. Ernst invents a dream-like planet, but he does not reproduce dreams. He himself asserts: "*I don't paint what I dream, but I dream as I paint.*"

Max Ernst. Single Tree and Paired Trees (1940). Oil on canvas done in a "frottage" technique. Thyssen-Bornemisza Collection, Lugano.

Other Representatives of Creative Surrealism

The absolutely subjective nature of dreams and of the subconscious results in there being as many Surrealist styles as there are Surrealist painters. Therefore, we can speak about the "Surrealism of Ernst," the "Surrealism of Magritte," and so on.

René Magritte (1898–1967) was a Belgian painter active in Paris of the 1930s. After passing through a Futurist and a Cubist phase, Magritte contributed new ideas to Surrealism. While painting realistic images in a photographic academic style, Magritte places them in a hallucinatory world in which his figures, the broad desolate landscapes, and the objects are as real as they are incongruent.

Ives Tanguy (1900–1955) practiced a Surrealism that greatly influenced the movement's later evolution. A painter of classical techniques and a precise and stylistically academic drawing, Tanguy portrays his subconscious world as populated by forms and objects that are utterly imaginary. Isolated commemorative stones (menhirs), floating locks of hair, soft stones are placed in desolate landscapes of vast horizons that define an essentially boundless space.

Surrealist Eroticism

Surrealism, in its more dreamlike digressions always conveys a certain erotic feel which is, at times, hidden in unreal or phallic forms and, at other times, personified by the nude figure.

René Magritte. The Lovers (1928). Oil on canvas, 74 × 54 cm. Private Collection, New York.

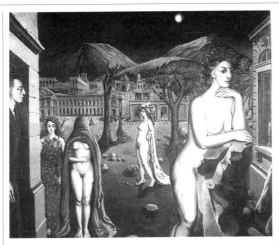

Ives Tanguy. Sun on a Pillow *(1937). Oil on canvas, 88 × 115 cm. Peggy Guggenheim Collection, Venice.*

Paul Delvaux (1897–1994), for example, is a formally classical and meticulous Surrealist whose compositions clearly reflect an uneasy eroticism. In his work titled *The Sleeping City*, characters and structures appear in an unusual scene in which, as if in a dream, the image of love is inaccessible, anguished, and evocative of death.

Dalí and His Critical-Paranoiac Surrealism

Salvador Dalí (1904–1989) received an academic training in art. This training and his admiration for Vermeer and Meissonier explain the euphuistic classicism that he incorporated in his Surrealist works. Dalí calls his Surrealist painting style, which he developed following a highly rational effort of experimentation, the *critical-paranoiac* method. The term *paranoiac* in this dichotomy stands for the absurd images he paints and which he attributes to his self-proclaimed genius. The term *critical* stands for the depiction of realistic spatial elements and actual objects that he executes in the midst of unreality.

His best compositions of the 1930s, such as *The Persistence of*

Paul Delvaux. The Sleeping City *(1938). Oil on canvas. Surrealist Art Center, London.*

Memory, abide by this dichotomy. In this work, the temporal elements (watches) have melting shapes and the spatial elements (reality that lasts) appear as solids. Dalí's dichotomy, painted in clearly classical style, is repeated in other works whose incongruous shapes have sexual connotations. *Construction with Cooked Beans: Premonition of the Civil War* is one of the most representative works of Dalí's Surrealism.

Main Ideas

• The Surrealist tendency manifests itself in different periods in the history of art.
• Surrealism of the twentieth century can be considered the plastic materialization of Freud's psychoanalytical theories.
• Figurative Surrealism is stylistically romantic (or discursive) and technically academic.

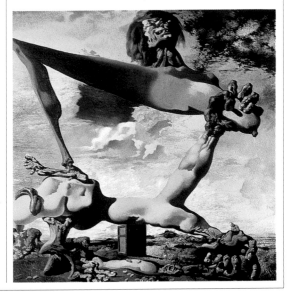

Salvador Dalí. Construction with Cooked Beans: Premonition of the Civil War *(1936). Oil on canvas, 99 × 99 cm. Philadelphia Museum of Art.*

NON-FIGURATIVE PAINTING

Non-figurative art, which in previous centuries had merely a decorative purpose, took an unexpected new direction at the beginning of the twentieth century. The basic elements of decorative art—material, texture, form, and color—have *their own intrinsic* aesthetic values. Many modern artists have experimented with these elements, without trying to give them geometric interpretations, without decorative pretenses and, of course, without claiming to duplicate models in real life, that is, reproduce figurative forms.

Wassily Kandinsky. Impression Number 5 *(1911). Oil on canvas, 157.5 × 106 cm. Nina Kandinsky Collection.*

Abstract Classicism, Wassily Kandinsky

The Russian Wassily Kandinsky (1866–1944) was the true father of abstract painting in the twentieth century and laid the basis of the style's theoretical underpinnings. In his writings, he defines the concept of abstract art and argues that form and color can convey a symbolic language of their own without any figurative purpose.

Kandinsky's art was intended to provoke pure aesthetic emotions in the viewers. His paintings carry no relevance to reality; they neither suggest nor convey anything that can be explained in words. Their only purpose is to evoke an aesthetic emotion that is as abstract as the titles of the works themselves: *Impressions, Stains, Ovals, Movements . . .*

Kandinsky once stated that his works were, "*for the most part,*

unconscious, spontaneous expressions endowed with an inner strength and a spiritual nature."

The English critic Roger Fly said of Kandinsky's *Impressions* that they were "pure visual music." Just as a Mozart sonata is pure music, so is a Kandinsky "*impression*" pure painting.

Symbolic-Surrealist Abstraction. Paul Klee

Paul Klee (1879–1940) was a Swiss national who studied in Munich. His works reveal an emotive surrealistic underpinning in

Paul Klee. A Young Woman's Adventure *(1922). Watercolor, 31.8 × 43.8 cm. Tate Gallery, London.*

which the figurative element, when present, dissolves into basically abstract compositions. Stylistically, Klee's broad and varied art production wavers between the purest graphic art and the creation of symbolic forms that embody great geometric lyricism. In time, his works developed a strong sense for design and chromaticism. Klee's chromaticism exhibits extraordinary tonal harmonies within carefully contrived and creative ranges and his designs are executed with precise, firm, and expressive lines.

Klee was well versed in music. In many of his works he seems to create a leitmotif that he handles, restates, and develops like a musical theme.

Joan Miró

The Catalonian Joan Miró (1893–1985) is another of the outstanding artists in the history of contemporary art. A convinced Surrealist (Bretón said about him that he was "the most Surrealist of all the Surrealists"), Miró's early works embody the fiery spirit of his native Catalonia. Later in his career, Miró relied on an original and unique language of symbols to infuse a discursive or story theme into his paintings. Understanding the narrative's symbolism requires that the painting be interpreted in its overall pictorial organization independently of any aesthetic impact it may convey. Discursive titles such as *Red-Winged Dragonfly Following a Serpent That Is Slithering Towards a Comet,* or his *Constellation. The Beautiful Bird Deciphers the Unknown to a Pair of Lovers,* are characteristic examples of Miró's symbolism that he uses to create a world in which tenderness and savagery are blended.

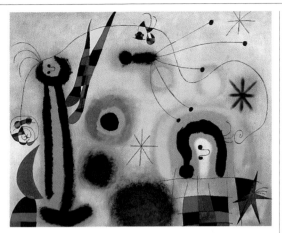

Joan Miró. Red-Winged Dragonfly Following a Serpent That Is Slithering Towards a Comet *(1951). Oil on canvas, 81 × 100 cm. Prado Museum, Madrid.*

The Plasticism of Mondrian

The Dutch artist Piet Mondrian (1872–1944) practiced a figurativism that sought the simplification of forms and that eventually evolved into geometric abstractions called Neoplasticism—a style similar in concept to Malevich's Suprematism.

Mondrian's aesthetic language is purely geometrical. Beginning in 1918, his paintings consisted solely of an array of horizontal and vertical lines in which only three basic colors appear: white, gray, and black. Mondrian's paintings are intensely rational. They consist of rectangles of pure colors whose harmonious association is based on mathematical principles and on musical theory.

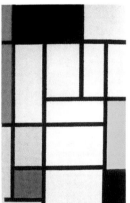

Piet Mondrian. Composition in Red, Yellow, and Blue *(1921). Oil on canvas, 50 × 80 cm. Municipal Museum, The Hague.*

The Suprematism of Malevich

After having experimented with Cubism, the Russian Kasimir Malevich developed a style he named Suprematism.

Suprematism proclaimed the superiority of the rational in a world where solid objects had no place. In this world, plastic forms are reduced to essential shapes: squares, triangles, and rectangles, painted in few colors that are flat, pure, and mostly white and black.

Malevich wanted to show that a painting could exist independent of any reflection on the exterior world or of any intent to imitate, in order to arrive at the expression of pure sensations.

Kasimir Malevich. Suprematist Painting *(1915). Oil on canvas. Peggy Guggenheim Foundation.*

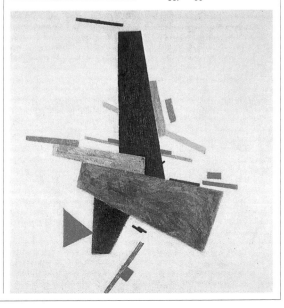

Main Ideas

• The goal of abstract painting is not to reproduce objects as they appear in the natural world, but to derive inspiration from an object's own attributes: form, texture, and color.
• Abstract painting produced a symbolic language (Suprematism and Plasticism), Abstract Expressionism, and others.

ABSTRACT EXPRESSIONISM

As often happens in art history, the emphasis on geometric abstractions provoked a stylistic counterreaction. The new abstract style argued for a return to values of spontaneity and intuition and proposed artistic expressions more attuned with feelings than with logical reasoning. In Europe, the new movement became known as Lyrical Abstraction while in the United States it is known as Abstract Expressionism. In Europe, it gave way to Informalism, an undercurrent that drew its artistic inspiration from the aesthetic value of the material.

Mark Tobey. Urban Radiation *(1944). White writing. Feiminger Collection, New York.*

The *White Writings* of Mark Tobey

The American artist Mark Tobey (1890–1976) created an Expressionist style influenced by Oriental calligraphy.

In his paintings of the 1930s, he used Chinese and Japanese writing characters that had no meaning as words, to create works of an extraordinary expressive interest.

In his *White Writings* paintings, Tobey uses the characters as aesthetic elements that he repeats endlessly. Tobey constructs authentic webs of white characters on dark backgrounds. The impression the work conveys is that of a myriad of shades, varying depths, grid-like arrays—a plastic universe that is as elusive as it is still.

New York Abstract Expressionism

Abstract Expressionism, which was initially dominated by Gorky and De Kooning, reached its highest artistic levels in New York.

Arshile Gorky (1904–1948), an Armenian who came to the United States in 1915 and whose early works were influenced by Miró, painted in a symbolic and formal abstract style.

After 1940, Gorky embraced Abstract Expressionism. His works combine linear elements with masses of color inspired by Miró, to form delicate structures that suggest animal and plant worlds with erotic connotations.

His oil canvas titled *The Betrothals II* is famous because it marks the transition between Mironian Abstract Surrealism and American Abstract Expressionism.

Willem de Kooning (1904–1997) was born in Holland and settled in New York in 1926 where he achieved his full potential as an artist committed to the modernity of his time.

Arshile Gorky. The Betrothals II *(1947). Oil on canvas, 95.5 × 129 cm. Whitney Museum, New York.*

In 1946 he began investigating Abstract Expressionism (improvised brushwork that relies on intuitive inspiration) and developed a highly personal style as seen in his canvas *Woman I* (1.93 × 1.47 meters). Here he blends form with pictorial space, creating grotesque, truly monstrous and, at times, terrifying female figures.

In de Kooning's Abstract Expressionist style, abstract forms are shaped with intuitive brushwork characterized by wide, vigorous strokes and by a predominance of greens and pinks.

Action Painting

Around 1947, a new variant of Abstract Expressionism emerged that one critic called *action painting*. Because it dealt with artistic creations that were strictly improvised, the new style could be compared to the free interpretations

Willem de Kooning. Woman I *(1950–1952). Oil on canvas, 147 × 193 cm. Museum of Modern Art, New York.*

in jazz music where musicians improvise as they perform.

Jackson Pollock (1912–1956) was the best known artist of *action painting*. He invented the drip technique, whereby streams of paint were allowed to drip onto large canvases spread on the floor from holes drilled in paint cans. With this technique, all image configurations disappear, leaving the canvas covered by interwoven arabesque shapes resulting from the artist's haphazard spreading of paint.

Pollock's paintings are "continuous paintings" in that even though they are limited by the length of the support, they have the potential to spread indefinitely on all four sides.

The Informalism of Jean Fautier (1898–1964). Fautier's works place an important plastic role on materials utilized. This is especially true for the series of paintings that he called Otages, or hostages. Precursors to Informalism, these works, based on

Jackson Pollock. Eyes on the color *(1946). Oil and enamel on canvas, 109.2 × 137.2 cm. Peggy Guggenheim Collection, Venice.*

grays and brownish-green tones, provide tactile sensations through materials that do not reproduce any recognizable form. The works are "informal," though not amorphous.

The Informalism of Antoni Tàpies

The artist who delved most deeply into the poetics of Informalism is without doubt the Catalonian Antoni Tàpies (born in 1923).

Tàpies' aesthetic ideas are based on the notion that pictorial material lacks formal structure (it has expanse but not form). He manipulates this premise in order to establish a creative relationship in what we might define as matter painting. In this technique, a highly "emotional" charge is given to surfaces that take on real tragic, pleasant, or dramatic values.

As someone has said, material becomes conscience.

Main Ideas

• Abstract Expressionism and Lyrical Abstraction are names used in the United States and in Europe, respectively, for the identical style.
• Informalism is a European variant of Abstract Expressionism that focuses on the plastic and expressive values of materials.
• Action Painting involves unpremeditated artistic creations whereby artists improvise spontaneously what they paint.

Antoni Tàpies. Relief in Ocher and Rose *(1965). Mixed Technique. Morris Pinto Collection, Paris.*

KINETICS AND OP ART

Kinetic art, which in the United States became known as Op Art (Optical Art), simulates virtual motion through playful optical effects. In effect, Op Art creates works that have both aesthetic value and provide visual relaxation.
Two Op Art techniques have emerged: a flat two-dimensional technique involving drawings or paintings of geometric shapes, graphics, stripes, and so forth, that blend to produce specific optical effects; and a second technique that superimposes on the painting's surface three-dimensional elements to provide the desired special optical effects.

Victor Vasarely. Triad *(1973). Denis René Gallery, Paris. The interaction between colors and figures produces the sensation of three rotating spheres.*

Victor Vasarely (1908–), born in Hungary and living in Paris, is without doubt one of the best known practitioners of Op Art. His investigation of virtual motion led him to study complex optical effects induced by squares, ellipses, or rhomboidal shapes drawn in different colors and tonalities. In his work *Triad* (1973), the interaction of forms and colors of three spherical cross-hatched surfaces gives viewers a sensation of virtual motion, as if the three surfaces were jointly rotating into the painting's surface.

The optical effects generated by Vasarely's works have made his paintings highly popular with the public and his style has found many admirers.

Bridget Riley (1931–) is an original English artist, author of black and white Op Art. She uses parallel lines in her works to achieve extraordinary visual effects in her works. The aesthetic merit of her creations are as much due to their optical effects as to their intrinsic artistic value.

Yascov Agam (1928–), an Israeli painter whose style combines flat colors with three-dimensional elements, is another of the great representatives of Op Art.

An example of his Op Art is his *Double Metamorphosis III,* a large mural covered with colored geometrical forms (circles, ovals, stripes, squares . . .) whose appearance changes according to the spectator's angle of viewing. This optical effect or virtual motion is induced by the vertical lattice covering the painting which, depending on the viewers' position relative to the mural, exposes to a greater or lesser degree the surface of the painting.

Pop Art, New Figurative Art

The so-called Pop Art (Popular Art) movement flourished in the United States and England as a reaction to figurative art. The style emerged around 1959 in the wake of a general malaise in non-figurative painting due to the stagnation of Abstract Expressionist inspiration.

Pop Art became most popular in the United States perhaps because it incorporated well-known cultural elements such as magazine photos, comic heroes, and ordinary objects. A style intimately tied to urban life, Pop Art became quickly accepted and assimilated into popular American culture.

Pop Art owes its figurative inspiration and derives its models directly from mundane items found in conventional environments. The model items then become subjects of paintings or are themselves glued onto the paintings. The items collated are often discarded or waste materials; the more trivial the item, the more relished the artwork is.

Yaacov Agam. Double Metamorphosis III, Frontal View. *Mixed technique. National Center for Contemporary Art, Paris. Forms and colors change depending on the visual angle of the viewer.*

The Three Greats of American Pop Art

Robert Rauschenberg (1925–) is considered the premier Pop artist. After espousing Abstract Expressionism, he shifted from informal themes to painting actual objects. In the years 1957–58, Rauschenberg practiced what was called *Waste Art*, a technique that derived its name from the type of objects he incorporated into his works: Coca-Cola cans, ties, license plates, and even dissected animals. However, after being awarded the first prize for painting at the Biennial of Venice in 1962, Rauschenberg changed techniques and created simpler artworks in which he used *frottage* to incorporate magazine photographs onto previously waxed canvases.

Roy Lichtenstein (1923–) is one of the true great representatives of Pop Art. Inspired by the aesthetics of comics, he has produced images through photomechanical reproduction techniques. The images are cold stereotypical macrovignettes that seem to convey the artist's

Robert Rauschenberg. Paris Review (1956). Lithograph. Magazine pictures are used for abstract inspiration.

Roy Lichtenstein. Boat Cover. Lichtenstein's stereotype macrovignettes convey a social myth quality.

intent to denounce the lack of communication among people.

Tom Wesselmann (1931–) popularized a series of paintings with the same title: *Great American Nude*. A kind of Pop allegory on eroticism viewed as a consumer product, these large paintings always portray the same elements: nude breasts, incomplete faces, cigarettes, apples These the artist renders in smooth colors. The images evoke in viewers a feeling of facing an inaccessible erotic window display.

Tom Wesselmann. Great American Nude No. 98 (1967). Ludwig Collection, Cologne. By repeating the title and intent Wesselmann presents a "window display" that ridicules the idea of eroticism.

Main Ideas

• Kinetic or Optical Art is an abstract painting technique that simulates virtual motion through optical effects.
• Optical effects in Op Art are achieved through two techniques: drawing and painting on a plane surface, or superimposing three-dimensional elements on a flat painting, so that the kinetic sensation perceived by spectators depends on their angle of viewing.
• Pop Art is a manifestation of popular urban culture that is inspired by mundane items found in conventional environments.
• Pop Art techniques range from collage (Rauschenberg), to photomechanics (Lichtenstein), and to actual painting (Wesselmann).

Original title of the book in Spanish: *Cómo Reconocer Estilos*
© Copyright Parramón Ediciones, S.A. 1996—World Rights.
Published by Parramón Ediciones, S.A., Barcelona, Spain.
Author: Parramón's Editorial Team
Illustrators: Parramón's Editorial Team

Copyright of the English edition © 1997 by
Barron's Educational Series, Inc.

All inquiries should be addressed to:
Barron's Educational Series, Inc.
250 Wireless Boulevard
Hauppauge, New York 11788

International Standard Book No. 0-7641-5015-4

Library of Congress Catalog Card No. 97-73624

Printed in Spain
987654321

NOTE: The titles that appear at the top of the odd-numbered
pages correspond to:

The previous chapter
The current chapter
The following chapter